BOOK OF SIDES II

Book of Sides II: Original, Two-Page Scenes for Actors and Directors is the second book in the *Book of Sides* series by Dave Kost, featuring original, two-page, two-character scenes for use in acting, directing, and auditioning classes. While shorter than the traditional three-to six-page scenes commonly used in classes, *Book of Sides II* features longer scenes than the first *Book of Sides* with greater character development, more reversals, and stronger climaxes.

- Balanced, structured scenes designed specifically for educational use challenge both actors and directors equally with objectives, obstacles, tactics, and subtext;
- Two-page length is ideal for high-intensity exercises and faster-paced workshops;
- Printed in easy-to-read film-script format with plenty of room for notes;
- Scenes are completely original and unencumbered by copyright, so students may film and post legally on the internet;
- Universally castable, so all roles can be played by actors of any gender, appearance, skill level, age, or ethnicity;
- Accessibly-written for modern students, helping them to focus on the fundamentals of performance and directing;
- Simple and conducive to performing in a classroom without sets, costumes, or special props.

This book was written by an educator *for* educators and designed for use in the classroom. Never search for scenes again!

BOOK OF SIDES II
ORIGINAL, TWO-PAGE SCENES FOR ACTORS AND DIRECTORS

Dave Kost

Routledge
Taylor & Francis Group

NEW YORK AND LONDON

First published 2017
by Routledge
711 Third Avenue, New York, NY 10017

and by Routledge
2 Park Square, Milton Park, Abingdon, Oxon OX14 4RN

Routledge is an imprint of the Taylor & Francis Group, an informa business

Library of Congress Cataloging-in-Publication Data
A catalog record for this book has been requested

ISBN: 978-1-138-22052-2 (hbk)
ISBN: 978-1-138-22055-3 (pbk)
ISBN: 978-1-315-41257-3 (ebk)

Typeset in Palatino
by Apex CoVantage, LLC

To Bob and Nelle, for all their love and support.

CONTENTS

Special Listings

The following listings are meant to help users who are looking for scenes with particular emotions or subject matter. Like the relationship column in the main listing of contents, these listings are not meant to restrict scenes to one particular interpretation, only to point out material that has the potential to be played in a particular way.

Anger
Bam!
Get Tested
Gimme the Remote
God
I Can't Win
I Want to Help People
I Was a Bully
I'm Trying to Apologize Here
It Happened to Me
It Sucked
The Keys
Let's Get a Picture
Let's Just Say Goodbye
My Place
Placeholder
Ring Food
Somebody's Been Talking
Take It Easy
That's My Bag
There Have Been Some
 Complaints
They Raised the Rent
They're Getting a Divorce
This Is It
We're Not Lost
What the Heart Wants
Where Were You?
You Can't Fire Me
You Like Everything
You Never Told Me
You People

Sadness
Bam!
Dating Is Weird
Different Scenes
A Friend Zone Thing
He's Our Responsibility
I'm Trying to Apologize Here
It's Grief

Left Alone
Move On
Placeholder
Run for It
Somebody's Getting Unfriended
They're Getting a Divorce
Why Aren't You Sleeping?
You're a Snob

Grief
Bam!
It's Grief
Placeholder
Still Family
They're Getting a Divorce
This Is It

Fear
Are You Shot?
Coming Out
Dating Is Weird
Don't Talk Like That
Haunted
I Feel Terrible
Is That Ashley?
It Happened To Me
It Must Be Good
It's Not Rational
Leaders Don't Cry
My Place
One, Two, Three
Run for It
These Aren't Zombies

Trust
Are You Buzzed?
Bam!
Be Real
Coming Out
A Date or Something
Domestic Violence

Don't Be Stupid
Don't Talk Like That
Fast Learner
Get Up
He's Our Responsibility
I Can't Read
I Can't Win
I Feel Terrible
Introduce Me
Is That Ashley?
Is This an Intervention?
It Happened to Me
It's Grief
It's Not Rational
It's Not Terrible
The Keys
Left Alone
Let Me See Your Phone
My Place
None of My Business
None of Your Business
One, Two, Three
Run for It
Some Kind of Scam
Somebody's Been Talking
Still Family
Take It Easy
That's My Bag
There Have Been Some
 Complaints
These Aren't Zombies
They're Getting a Divorce
Too Many Detective Novels
We're Not Lost
What the Heart Wants
You Never Told Me
You Should Exercise More

Power
Are You Buzzed?
Are You Stealing?

Beats Digging Ditches
A Friend Zone Thing
Get Tested
Gimme the Remote
God
Great Seeing You
The Hand You're Dealt
He's Our Responsibility
High Standards
I Can't Win
I Just Want a Raise
I Want to Help People
I Was a Bully
I'm Trying to Apologize Here
In a Scene
Introduce Me
It Sucked
The Keys
Left Alone
Let Me See Your Phone
Let's Just Say Goodbye
None of Your Business
One, Two, Three
Partners
Rich–Poor Stuff
Somebody's Been Talking
Something Permanent
That's My Bag
There Have Been Complaints
There's a Reason People Relapse
This Isn't Fun Anymore
Too Many Detective Novels
Unrequited Love Is a Thing
We're Not Lost
What the Heart Wants
Where Are We At?
Where Were You?
You Can't Fire Me
You Like Everything
You People

Flirtation
Be Real
A Date or Something
Dating Is Weird
Fast Learner
High Standards
I Can't Read

Introduce Me
It Must Be Good
It's Not Rational
It's Not Terrible
My Place
A New York Minute
No Regrets
Not in Real Life
Ring Food
Something Permanent
Stars and Skulls
Those Feelings
Two Weeks
Unrequited Love Is a Thing
Why Aren't You Sleeping?

Breaking Up
Aren't We Broken Up?
Get Tested
God
Let's Just Say Goodbye
Move On
A New York Minute
One, Two, Three
Rich-Poor Stuff
Something Permanent
There's a Reason People
 Relapse
This Is It
This Isn't Fun Anymore
Those Feelings
You're a Snob

Crime
Are You Stealing?
Bam!
Domestic Violence
Great Seeing You
I Just Want a Raise
It Happened To Me
My Place
None of My Business
Partners
Run for It
Some Kind of Scam
Somebody's Been Talking
That's My Bag
Too Many Detective Novels

You Can't Fire Me
You Never Told Me

Substance Abuse
Are We on Drugs?
Are You Buzzed?
Different Scenes
Get Up
Great Seeing You
Is This an Intervention?
No Regrets
One, Two, Three
Our Problems
Real Addiction Problems
There's a Reason People Relapse

Health/Mental Health
Crazy Like Van Gogh
Different Scenes
Don't Be Sick in Here
He's Our Responsibility
Hypochondriac
I Feel Terrible
It's Not Rational
Left Alone
Where Were You?
You Feel Okay?

Supernatural
Haunted
Not the Telepathy
These Aren't Zombies

Creativity/Criticism
Beats Digging Ditches
Crazy Like Van Gogh
The Hand You're Dealt
High Standards
In a Scene
It Must Be Good
It Sucked
It's Not Terrible
You Like Everything

Comedy
Are We on Drugs?
Aren't We Broken Up?
A Date or Something

ACKNOWLEDGMENTS

My appreciation to all those who reacted so positively to the first *Book of Sides*. Without that book's success, this sequel would not be possible. Thanks especially to all those who made the effort to reach out to me and my publisher with their kind words and positive feedback about that book, and particular gratitude to those who suggested that the slightly longer scenes in this book would also have an important place in acting and directing education.

A huge thank you to all those who helped in the review process for this book, particularly to my friend and colleague at Chapman University, Jay Lowi, and the always insightful Jack Sholder of West Carolina University who served as official reviewers on the first *Book of Sides* and returned to review this new effort. My gratitude as well to Dr. Matthew Ames and Andrew Papa who were the official reviewers of this book's proposal.

Thanks to my many former students who are now teaching or working in the industry and took the time to share their thoughts with me about the book, including Matthew Allen, Prarthana Mohan, Saqib Siddick, Matt Tegtmeier, and Rob Warzecha. I also received great notes from my good friends Boyd McCollum and Tim Diamond.

The photographs for this book were shot by Chapman student Kayla Hoff with the help of Sebastien Nuta and Adrian Nieto. The subjects in the photos are Chapman and California State University Dominguez Hills students Aurelio De Anda, Alejandro De Anda, Francesca Artalejo, Marilyn Felix, Nikolai Gednov, and Vincent Richmond, as well as professors Kelly Herman, John Benitz, and myself.

Many thanks to my friends and colleagues at Chapman University who were kind enough to take time to give me notes, including John Badham, John Benitz, Tom Bradac, Gil Bettman, Pavel Jech, Andy Lane, Michael Nehring, and Andrew Wagner. Moreover, thanks to all my fellow professors and administrators at Chapman University. It is truly a pleasure to work with every last one of them.

The students at Chapman University have been working with the scenes from my previous book for several years now. Seeing those scenes performed in classes and shot as projects has been a huge inspiration. I especially appreciate the talented performers in Chapman's Screen Acting program. Working with them is where I discovered the need for these books, and seeing scenes from both that first book and this new book performed by these talented young actors has been incredibly useful in developing the material. Thanks to all my students. Their energy, creativity, and eagerness to learn are a constant inspiration to me.

Finally, my greatest thanks to my wife, Kelly Herman, who teaches at Cal State Dominguez Hills. She is my frequent partner in brainstorming and always my first and best source of feedback.

FOREWORD

If parts of this foreword sound familiar to those who have read the foreword to the original *Book of Sides*, it is because the principles of this book are very much those of the previous book. The main difference between the two books is the length of the scenes. The one-page scenes in the original will be appropriate for some types of scene work (frequently, but not always, beginning-level work), while the two-page scenes in this book will be appropriate for other types of scene work (frequently, but not always, intermediate-level work). The scenes in both books are different from all those in other scene books in a number of significant ways, which allow them to be used in new and exciting ways in any acting and directing classes where scenework is being done.

Scenework provides the real bulk and substance of the education of both actors and directors. It lies between theoretical study and the mounting of complete films or theatrical productions. It is where aspiring actors and directors can acquire most of their experience, taking risks, getting mistakes out of the way, and building good habits.

A musician can only learn so much from a book and will only master their instrument by actually playing it. At the same time, it is not practical or advisable that aspiring musicians leap directly into performing in concerts. Instead, they do what only makes sense, spending the bulk of their musical education practicing. Practice makes the basics come easy, almost automatically, allowing more and more concentration to be shifted to nuance, detail, and the perfection of the craft.

Such is the pattern in the learning of all arts and crafts. Graphic artists won't master their skills reading books and they won't start off making masterpieces. Aspiring writers need to write, but should not begin by attempting a novel or a screenplay, and aspiring dancers need to practice dance, but need to start with the most basic of steps.

In serious training, early education will be dominated by simple exercises, and this may be even more important in film and theater, where actual productions demand so much effort and so many resources. Scenework requires only actors, a director, and a little space, yet it provides the essential experience from which actors and directors will grow. The material in both versions of the *Book of Sides* has been specifically designed to maximize the benefit of scenework.

Best of all, scenework, like its counterparts in other arts education, can be mentored in a classroom setting. When a scene is workshopped with a skilled instructor, aspiring actors and directors can be guided through the process of creating convincing and dramatically involving performances, helping them to understand what habits to build on and what

mistakes to avoid. There is no other activity that can get more economically to the core of what actors and directors most need to practice and learn.

It is the aspiration of this book, like its predecessor, to provide new options for scenework that will facilitate different learning experiences. For reasons that have more to do with the available source material than the needs of scene workshops, previously available scene books featured scenes usually ranging in length from four pages to eight pages. There is generally nothing wrong with these scenes. They are frequently the work of great writers of the stage and screen and have been used to successfully train actors and directors for decades. This book will not displace those books. Instead, it will complement them, providing not just shorter scenes, but scenes with a number of unique features.

In most cases, students can learn as much from attempting a short scene as they can from a longer scene with the additional advantage that more students will be able to attempt scenes in the same amount of time. This will be particularly useful in crowded classes, since these shorter scenes will allow far more students to work during a given class session and allow students to act or direct more scenes over the course of a semester. In addition, shorter scenes can be more effective when focusing in on one narrow aspect of performance at a time. This book and its predecessor are designed to facilitate this learning approach.

Beyond their length, the scenes in this book are unique because they are original while almost all other scene books are compiled from existing play or movie scenes. Both versions of the *Book of Sides* feature scenes specifically designed by an educator for teaching purposes. As a result, the scenes always challenge both actors equally, suggest subtext and objectives for both characters, and are structured with conflict, reversals, and a beginning, middle, and end. Most uniquely, these scenes were made to be universally castable, something impossible with scenes from existing material that invariably prescribe the gender of the characters and sometimes age, ethnicity, or type as well. By contrast, the scenes here allow instructors, directors, or actors to choose scenes at random and still be assured that the material will be appropriate and challenging.

These scenes also keep props to a minimum and are not specific in setting. This makes them both easy to perform in a classroom setting and easy to film as an exercise. In short, these scenes are designed to be the ideal teaching tool for acting and directing classes. Never again will instructors and students have to hunt for appropriate scenes to use in classes.

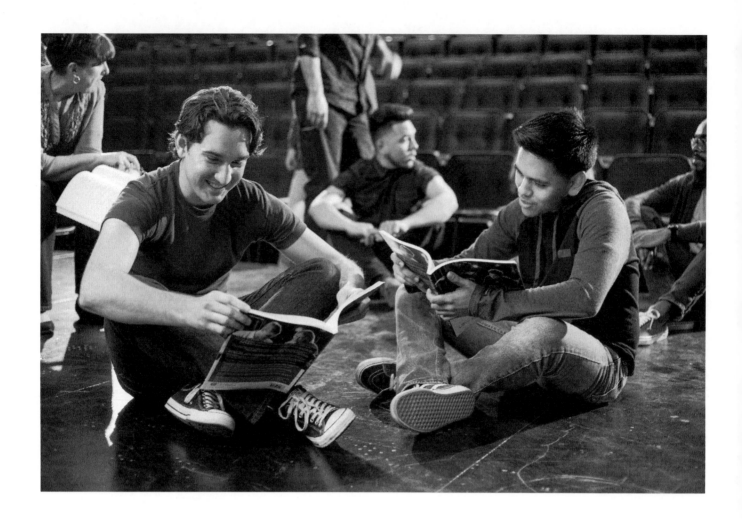

INTRODUCTION

The introduction to the first *Book of Sides* focused on using that book in scenework with the particular aim of utilizing the short length of the scenes to focus more narrowly on one particular aspect of performance at a time. From an educational perspective, students generally absorb a simpler lesson more effectively. If students, especially beginning students, are confronted with performance notes about truthfulness, emotion, conflict, structure, subtext, and blocking all at the same time, they are likely to be overwhelmed and retain little. When lessons are focused, students are more likely to retain and synthesize knowledge, and topics can be made appropriate to where individual students are in their learning.

It is the intention of this introduction to promote and facilitate this same, incremental learning approach to scenework, but rather than repeat the first book's introduction, it will be expanded upon here. The first book's introduction described the many aspects of performance that could potentially be focused on in scenework, while this introduction details exercises that are specific to addressing these various areas.

There is a whole body of great literature about acting and directing, and I encourage those serious about these fields to read extensively on the subject. The following is a brief summary of a variety of common scenework exercises that is presented here to help those using this book.

The variations on scenework outlined here can be used by instructors with student actors or by student directors with their actors. In some cases, actors can apply these techniques to their own performances while they are rehearsing. This introduction is written as much as possible to be applicable to all three audiences. It is also written as much as possible to be applicable as both a primer for beginners or as a review for those with more experience.

SCENEWORK

Scenework is the performing of simply mounted scenes as a means of improving the skills of the actors and directors through practice and critique. In order to meet its educational purpose, there is no need to complicate scenework with sets, costumes, or special props.

Even when scenes are shot and edited—as is advisable at times for those studying film directing or screen acting—there is no need to put effort into production value. In most cases, a location should be selected for convenience and any well-lit, sound-friendly environment will do. The objective is to keep the production simple and focus on specific performance goals, so that the skills related to these goals can be improved.

Getting the Most Out of Scenework

Students need to embrace the right process in their approach to their work. Whatever the exercise, students should keep in mind the goals of any performance and approach the work like an aspiring professional.

Although scenework is "only" practice, it needs to be approached with the same effort, energy, and preparation as a professional production. This builds the discipline necessary to be successful in a highly competitive field. What is learned from scenework is proportional to the effort put into it.

There should be less pressure in scenework than in a fully realized production. The work still needs to be taken seriously, but the participants should feel free to focus narrowly on specific aspects of performance and be willing to try varying approaches and take more risks. Embracing a process of growth and not worrying about results is what the exercises outlined below are all about. Learning occurs at the edge of one's ability, so stumbles should be as common as triumphs. Both will be opportunities to grow, especially when accompanied by the feedback of instructors and peers.

SCENEWORK EXERCISES

Scenework in many acting and directing classes is simply performing the scene and receiving notes on the performance. In many cases, the students will get a chance to incorporate the notes into additional performances of the scene. While this introduction addresses more directed approaches, scenework of any kind will always be beneficial.

Students will learn most effectively by focusing on a particular aspect of performance that is appropriate to where they are in their education. The exercises below are organized to facilitate this. Some exercises are useful in addressing more than one area of a performance and this is noted where applicable.

BELIEVABILITY

A believable performance allows an audience to transcend the reality that they are watching two actors perform and instead involve themselves in the lives, emotions, and struggles of the characters that the actors are playing. Believability is not synonymous with realism. It has more to do with the truthfulness of the underlying emotion and behavior.

Self-consciousness

The believability of those new to acting is undermined when they are self-conscious, thinking about their performance or worrying about embarrassing themselves instead of living truthfully in the imaginary circumstances of the scene. Actors need to behave as the character instead of behaving as the actor portraying the character.

For actors who are simply nervous while performing, there is no substitute for the confidence that will come with experience. Scenework of any kind will provide experience and build confidence, but beginning actors will gain more confidence by keeping their performances simple. They should play characters that allow them to draw on themselves and avoid stylistic or technical challenges till they build more confidence.

Beginning actors who are struggling with self-consciousness may be better off to limit their performances physically by simply sitting. Once they gain more confidence, actors

can begin to take on the physical dimension of their performance. Exercises that help with physicalization are described in the section later in this introduction on blocking.

Self-consciousness frequently manifests as physical tension, vocal tension, or stiffness. Taking time to loosen up the body by shaking out tension or loosen up the voice by singing or vocalizing right before performing a scene can help tense actors unwind. Deep breathing before a performance or even before each line within a scene can also help them to relax.

Objectives

Making sure actors want something from each other helps to improve believability and reduce self-consciousness because it makes the other actor the object of their attention instead of themselves. In addition, the character's objectives are a big part of the story that is being told. For both reasons, objectives are one of the most fundamental concepts in acting.

Objectives will sometimes be clear from the text, but when they are not, it is a great exercise to push for an insight into a deeper level or even take a leap of imagination to find an objective, but it is always possible for a character to have a want.

An objective can be specific like, "Get the other character to admit their love" or "Get the other character to leave," but it can also be less concrete, for example, "Get your power back from the other character," or "Get the other character on your side." All these examples direct action toward the other character because a good objective focuses the actor on affecting the other character. "Be strong," "Grieve," or "Explode" are poor objectives because they do not involve the other character.

Objectives are also the motor of conflict in a scene. There is more about this in the section later in this introduction on dramatic interest.

Indicating

When actors seem to be constructing a performance to show us what they are thinking and feeling rather than authentically thinking or feeling, we call this indicating. Indicating is a form of self-consciousness that undermines believability. It may accompany nervousness, but confident performers can also fall into the trap of contriving a performance.

An exercise that can help with indicating is to introduce an activity into the scene. Activities in finished performances should make sense for the scene and the character; for instance, a character about to leave on a trip might be packing. However, for the purposes of an exercise to free an actor physically or make them less self-conscious, an activity need not be related to the scene at all. For instance, keys can be hidden on stage and the actor must find the keys while playing the scene. Coins might be scattered on stage, and the actor must gather them up, or an actor might have to draw a picture, arrange chairs, or put a deck of cards in order. In these cases, the activity may free the actor from their preconception of how to play the scene, and make them behave more truthfully.

Listening

Believability often hinges on whether the actors sound like they are spontaneously responding to one another rather than just reading lines. Exercises that can help actors listen, process, and react more authentically often involve repetition. These techniques were popularized in the acting training pioneered by Sanford Meisner.

In a basic repetition exercise, an actor repeats out loud the line or the end of the line that was just delivered by the other actor in the scene before they deliver their own lines. This technique forces an actor to focus on what the other actor is saying rather than being strictly in their own head, thinking about delivering their next line. Better listening, processing, and reacting results in a more believable performance and improved spontaneity in the exchanges between actors. Repetition exercises can also be useful in slowing down actors who are rushing their performances or stepping on their scene partner's lines (beginning their line before the other actor's previous line has been completed).

In another repetition exercise, an actor repeats the other actor's line with a particular delivery that reflects their character's attitude about what the other actor has just said. In this exercise, an actor might sincerely deliver a line, but when their scene partner repeats that line, they might deliver it with sarcasm, indicating that they are interpreting the other character's intention as insincere.

Actors may also repeat the line or the end of the line that was just delivered by the other actor silently to themselves before delivering their own line. Because the result of this technique is that the actors seem to simply be thinking about what the other actor has said before replying, it can even be used in finished performances. It can be a particularly interesting exercise to film. If it is filmed with angles on both actors, a skilled editor can tighten the slow pacing that comes with this technique and the results can be rewarding.

Repetition is not the only technique that can help with listening. Cold-read exercises, in which actors perform scenes by reading directly from scripts that they are unfamiliar with, can also help students to be better listeners and more spontaneous in their interactions.

Character Building

Also basic to the believability of the scene is the sense that the characters in a scene are complete people, that they have dimension with full lives and histories and don't seem to exist just to be in this scene delivering these lines.

The most basic way to build character is for actors to bring more of themselves and their own unique personality to their characters. Asking an actor questions like, "How would you feel if this happened?", "Has anything like this ever happened to you?", or "What would you do here?" can encourage them to incorporate more of themselves into their performance.

Actors can also be prompted to fill in the given circumstances of the scene with their imaginations by asking them questions like, "What were you doing right before this scene began?", "What is your relationship and history with the other character?", "How is your behavior modified by where the scene takes place?" or "What is in your character's past that makes them react the way they react?"

Characterization can be worked on by changing the back stories of the characters and seeing how it affects performance. The short scenes in the *Book of Sides* are particularly useful for this exercise because they are generally open to different interpretations. Challenging an actor to portray different versions of a character can help them to realize how much this affects the way the scene is played and also help them realize their own potential in exploring a character and giving them more than one dimension.

Instructors or directors can suggest various ways of changing the personal history of a character. They might make a general suggestion about a character's level of education

or class or a very specific suggestion, like inventing an event from a character's past that affects their behavior in this scene. They might also change the relationship of characters in the scene, or suggest something that might have happened just before the scene began (the moment before). Also, since in most cases the scenes are being performed in a class, the setting of the scene can also be altered in the actors' imaginations.

Changing the backstory, the moment before, or any part of the given circumstances for an actor can also help with the spontaneity of their scene partner who will have to react to the new behaviors that result from these changes.

Emotion

The believability of a performance also hinges on the truthfulness of the actor's emotion. All storytelling is meant to explore human emotion. It is central to any performance, but it needs to appear genuine and appropriate to the scene.

Some actors may have difficulty producing enough emotion for a performance. An exercise that may help an actor to find the emotion in a scene is asking them to find a substitution from their own lives that will help them connect with the character's emotion. For instance, in a scene in which a character is losing someone they care about, they might try remembering someone they have lost or try imagining losing someone who is still in their lives. It may even be useful for them to picture the other actor in the scene as the person they care about.

Substitution is a popular technique, but it is not without controversy, because some feel that tampering with an actor's actual emotions can be dangerous. If attempting this exercise, particular care should be taken by the instructor or director to ensure that the actor is comfortable incorporating their own emotions into their performance. Another criticism of substitution is that it puts actors too much in their own heads and prevents them from being fully involved with their scene partners. This is, however, a critique of using it in a finished performance, more than in an exercise.

Living more truthfully in the imaginary circumstances of the scene can help actors by allowing them to genuinely experience the emotions of the characters. Improvising an introduction to a scene can help actors imagine the emotion of a scene as can simply talking the actors through how they are feeling before beginning the scene.

While some actors may have difficulty producing emotion, others may produce too much. Actors should not be discouraged from being emotional, so a good exercise to moderate an overly emotional actor is to ask them to reconceive their character as a person who feels things strongly, but will do all they can to keep their emotions hidden from others.

Assigning an activity as described in the section on self-consciousness earlier in the introduction can also help an overly emotional actor, especially one who seems to be forcing emotion into their performance.

A scene falls apart when the emotions of the two actors in the scene are out of sync. This happens when an actor is not truly engaged with their scene partner. Instead, they present their own personal interpretation of the scene, a form of indicating.

An exercise that can help actors be better engaged with each other emotionally is to require them to perform a version of the scene without ever breaking eye contact. Variations on this exercise may also have the actors hold hands and/or sit or stand very close together.

Some actors are good at portraying some specific emotions, but struggle with others. For instance, an actor may be effective in depicting sadness, but less so when they must be angry. Actors should be encouraged to attempt material that challenges them to deepen and expand their emotional range. There are listings after the table of contents in this book that can be used to find material that will help to challenge actors to explore specific emotions like sadness, anger, or fear.

DRAMATIC INTEREST

Though sometimes underappreciated in acting classes, a critical goal of all scenes is the creation of dramatic interest via performance. A performance will not be watchable merely because it is believable or has emotion. It should be dramatically engaging as well. Some writing will be more dramatically effective and some less, but it should always be a goal of the actors and the director to engage the audience with the story.

Subtext

Subtext refers to the emotions and intentions that lie beneath a character's surface and it is critical to building dramatic interest. Characters having a polite exchange of dialogue will be fairly boring to watch, but if there is hostility bubbling just below the surface in the same exchange, it will be fascinating. Subtext involves the audience in interpreting what is really going on between characters and makes them active rather than passive observers of a scene.

A stronger objective will often help actors with weak subtext. Sometimes actors don't see the obvious potential for subtext in a scene and need to be pointed toward it by having their underlying objective articulated to them. Other times, the subtext of a scene may not be obvious and can only be arrived at through a leap of imagination that finds a deeper, more important objective in a scene. If a scene ever feels petty, like two characters are just bickering, this is because the actor's objectives are weak, but this scene can grab an audience if it is played with the intention that it is actually an epic power struggle.

An exercise that can help with subtext is to have the actor deliver their line and then briefly state their subtext quietly afterwards. For instance, if the actor delivers the line, "I hope you're well" insincerely, then they might simply add the word "... not" afterward or perhaps, "... drop dead." In this exercise, the actors are stating their intention out loud and this allows directors and instructors to see whether they have chosen strong subtext and whether they are conveying it in their intention.

While some actors fail to play subtext, others can overplay it and it can become indicating. Giving an actor an activity as described earlier can also help with overplayed subtext.

Overplayed subtext is particularly problematic in screen acting, especially when the audience should pick up on an actor's subtext, but the other character in the scene should not. Sometimes, actors play the subtext so strongly for the audience that it becomes unbelievable that the other character does not pick up on it.

An exercise that can help actors be more subtle with their subtext is allowing each actor to provide outward feedback about whether they are buying the sincerity of what the other character is saying or not. This can be done by having the actors nod "yes" or "no" after each of their partner's lines or by saying something like "lies" or "bullshit" any time the other actor seems insincere. A variation on this exercise requires the actor who has been called out for a lack of sincerity to repeat their line till the other actor believes them, and only then can the scene progress.

Creating a private moment for a character is a great way to share subtext with the audience but not the other character in the scene. A private moment is a moment of secret behavior or unguarded emotion expressed by a character when they think they are alone or unobserved. A private moment may be indicated in a script, but even if it is not, there may be an opportunity to create one before a character enters, after a character leaves, or at a moment where one character is not paying attention to the other.

Conflict

Audiences love conflict because they relate it to the struggles in their own life. If a character can easily obtain their objective, there will not be much dramatic interest. They need to encounter an obstacle. The main conflict in most scenes is produced by the opposing objectives of the characters in the scene. Another way to think about this is that the obstacle preventing a character from obtaining their objective is often the other character in the scene.

The basics of objectives are discussed earlier in the section on believability, but frequently the issue is not that the actor lacks an objective, but that the objective is weak. In these cases, a stronger objective that is in better opposition to the other character is needed.

An actor may have only interpreted the surface of a scene, in which a character wants something simple like keys or a remote control. Making this trivial thing the objective of the scene is not as strong as an objective like putting the other character in their place or regaining control. In this way, conflict is linked to subtext. In many cases, the real objectives in a scene should not be immediately apparent, but deeper, related to the character's inner life and expressed only through subtext.

Internal Conflict

Conflict may be external (the conflict between characters) or internal (the conflict within a character). In other words, the obstacle keeping a character from their objective may be another character, but it might also be some aspect of their own personality. An internal obstacle is particularly useful in bringing conflict to a scene with no apparent external conflict. Watching someone wait in line should be boring to watch, but if the character is waiting to meet someone they care about and is simultaneously excited and afraid of making a fool of themselves, even this will have dramatic interest. Inner conflict also adds dimension to a characterization and is what leads to a real internal change or character arc.

Most scenes combine both external and internal conflict in order to create complexity and depth in the drama. A scene in which a couple struggles because one desires more commitment and the other does not will quickly reach an impasse if both characters are completely set in their positions, but if one or both characters are unsure or internally conflicted about their positions, there is much more room for conflict to develop.

If an actor is having trouble adding internal conflict to a scene, they may need help crafting a single objective that encompasses both their external and internal objectives. For instance, an actor playing the objective "Break up with the other character" could have this changed to "Prove that you are right to break up." "Ask this girl out" could be changed to "Ask this girl out without embarrassing yourself." Objectives that imply uncertainty or struggle within the character can lead to a more complex and nuanced performance than playing a one-dimensional objective that seems easily achieved.

Need

Sometimes, the conflict is weak in a scene because characters don't adequately need each other. Actors can fall into this trap once they have come to appreciate the importance of playing an objective. They play so hard to win that they lose all sense of relationship. If so, the audience wonders why the characters don't simply go their separate ways. An obvious example is any scene between lovers, which will be more compelling if the audience can see the love as well as the conflict between them, but almost any scene will benefit from stronger need between characters.

Actors can build a sense of need by imagining the other character in their scene is someone they really love, wouldn't want to offend, or whose approval they desire. Actors might also try substitution, imagining their scene partner is someone from their own life. Substitution exercises come with some reservations as expressed earlier in this introduction in the section on emotion.

Another exercise that can help with need is giving the actors an "as if." For instance, if it is a scene in which a breakup seems to be happening very easily because the love between the characters is not very apparent, the actors can be given the adjustment to play the scene "as if" they can't stand it when the other character cries and they must do everything in their power in the scene to avoid hurting the other character's feelings.

Story

Actors are storytellers and ultimately their job is to use their performance to engage an audience in a story. Much of the story comes from the script, but the actors are responsible for interpreting the story and presenting it in a way that is involving and dramatic.

Playing the Result

A scene will provide more dramatic interest if the outcome of the conflict seems uncertain to the audience. How will the conflict resolve? Who will prevail? Because the actors know how the scene ends, they sometimes fall into the trap of playing the result or playing the whole scene with the emotional note of the scene's ending. This telegraphs the outcome to the audience and disengages them from the story. The actors need to discover the story as their characters are discovering it. A simple exercise to help actors who are playing the result is having them commit to the opposite outcome. For instance, in a scene about estranged lovers who try to reconcile but fail, an actor would try to start the scene certain they are going to succeed at reconciling.

Structure

Uncertainty of outcome is stronger and dramatic interest higher when the likely outcome of the conflict seems to shift. In a two-character scene, this simply means that it should seem like one character will prevail at first then later seem like the other character might prevail. Even a short scene might have several of these reversals, providing structure and a progression to the piece.

The scenes in this book generally provide at least one clear reversal, but actors can work to create more shifts even when they are not apparent in the script by performing the scene while the instructor or director gives them an offstage or off-camera instruction that alters the likely outcome of the scene in their minds. For instance, the instructor or director might

first say, "You are definitely getting back together," but then a few lines later might say, "This was a huge mistake," and then after a few more lines, they might say, "This may work out after all." This exercise can also improve spontaneity and benefit an actor who has been playing the result.

Tactics

The specific ways in which the characters try to achieve their objectives are their tactics. The characters should start with strong tactics, but they should change tactics frequently, especially when a tactic doesn't work. Actors will need to counter each other with stronger and stronger tactics if the scene is to intensify. Like objectives, tactics are a basic part of all acting and directing training. Changes in objectives, obstacles, or tactics create acting beats. These beats create a rhythm, variety, and escalation that engage an audience in the story.

Some actors will still struggle to find strong tactics, so teachers and directors may suggest stronger tactics to the actors to employ in the scene. The strongest tactics are usually action verbs, meaning something the character actually does as opposed to a state of being. For instance, "seduce" is an action, something that someone does to someone else, as opposed to "be sexy," which is only a state of being. A good test for an action verb is whether it will take an object in the grammatical sense. For instance, you can "seduce" somebody (somebody being the object), or "intimidate" or "demean" somebody. But you cannot "be sexy," "yell," or "sarcastic" somebody. Extensive lists of action verbs for actors can be found in many acting books or on the internet. Just search for "Actor's action verbs."

Other actors may have trouble varying or escalating their tactics. Actors can be counseled about tactics before the scene begins or as an exercise, tactics can be given to them while the scene is in progress. Changing tactics in this way can also help an actor with their spontaneity.

"As ifs" can also be useful with tactics, generally as modifiers that can give an action verb a flavor that it might not normally have like "implore her *as if* you are a starving puppy" or act as an intensifier for an actor who is too casual in their performance. For instance, "intimidate him *as if* you've been waiting your whole life to finally get the upper hand on him."

BLOCKING AND PHYSICALITY

Blocking is the way the actors physicalize their performances and the way these physicalizations relate to one another. The blocking is as important as the way lines are delivered and can help to express emotion, subtext, conflict, tactics, and relationship. There is nothing wrong with early scenework being performed from a seated or simple standing position; however, even at an intermediate level, the scene should be physicalized and blocked.

Physicality

Some actors have difficulty moving freely and may not even know what to do with their hands while performing. Movement is an entire branch of acting training and freeing an actor physically may require a great deal of study. That said, exercises can help physically awkward actors, starting by simply loosening up physically before the scene as mentioned earlier in the section on self-consciousness. Giving the actor an activity as described earlier in the section on indicating can also help an actor who is physically constrained.

Exercises that have the actors physically affect each other in the scene are quite effective. Variations on this exercise might have the actors tug a rope or string back and forth, or stand touching palms and try to push each other off balance. This exercise is freeing physically and also helps tie the actor's physicality to their objective and tactics. A character seducing their scene partner pushes them off balance very differently than a character intimidating their scene partner.

Another way to physicalize a scene is to have the actors walk around slowly, while one pursues the other. In another variation, one actor tries to leave and the other tries to block their way. Be careful to keep the actors slow and calm in this exercise so no one gets hurt, and make sure the physicality remains an expression of subtext and doesn't turn the scene into an all-out chase or fight.

"As ifs" can be very useful in developing physicality and blocking. A fun "as if" is to ask the actor to take on the physicality of an animal, not literally getting on all fours, but taking on the aloof preening of a cat, the attention-seeking energy of a dog, or the slithery smoothness of a snake. Other good "as ifs" for physicalization are playing the scene as if in constant pain, as if barely able to stay awake (good for overly energetic actors), or as if dying to go to the bathroom (good for low-energy actors).

Blocking

Since blocking is the way the actors relate physically to one another, it may be difficult for individual actors to coordinate and usually needs the guidance of the director to make it work for the stage or camera. Nonetheless, it is good for both actors and directors to gain an appreciation for the way blocking affects the presentation of a scene.

Blocking is frequently used to express the changing dynamic in a relationship. How close actors are physically can illustrate how close their characters are emotionally, and physical height (standing vs. sitting or kneeling) can show who has power in the relationship. This can be explored by blocking the scene in a way that translates every moment in the evolving relationship into a change of physical proximity or relative height.

Exercises that require a scene to be blocked in different ways help illuminate the effect blocking has on a scene's presentation. For instance, a scene can be blocked to direct attention to one character, making them seem to be the main character in the scene and then re-blocked to make the other character seem to be the main character. This exercise can be performed with stage blocking or with camera blocking.

An interesting blocking exercise for camera is to block a scene to be shot in wide shots with more emphasis on physical action and movement, then re-block the scene to be shot in close-ups with less physical action and more emphasis on reactions and the internal life of the character.

STYLE

Many styles of performance, including most comedy, require acting in a way that is not strictly realistic, but the performance still needs to be truthful, especially in its underlying emotion.

It can be a useful exercise to ask actors to perform a scene in a different style from their initial interpretation. For instance, actors who are playing a comedy scene broadly without any emotional truth may benefit from having to play that scene as a drama to see if it helps them connect with the emotion. On the other hand, a scene that seems either leaden or overwrought may benefit from being played as a comedy.

In addition to illuminating the way style affects a performance, this exercise helps to explore material and see more of its possibilities. Many actors and directors are quick to determine exactly what they want from a scene and then work toward a result rather than embracing the process and exploring a scene in a way that allows them to see more of its potential before arriving at the best interpretation. Aspects of different style exercises can be combined in the final performance, giving it more variety and less predictability.

The scenes in this book are not particularly prescriptive of style and, whatever the reader's first interpretation might be, all can be played as drama or comedy, so they will always lend themselves to stylistic variation.

TECHNICAL ACTING

Similar to the stylistic layers that can be added to a performance, technical layers can also be added. A technical layer might be a dialect, a unique physicality, or an impediment. Acting impediments may affect speech like a slur, a lisp, or a stutter. Impediments may also be physical like a handicap, illness, or injury. They may also be mental like drunkenness, mental illness, or mental disability. These are generally more advanced challenges for actors, but chosen well they can add dimension to a character and may also contribute to dramatic interest.

Simply attempting different technical adjustments to a performance is an excellent way to work on these skills and a good way to explore the potential of the material.

DIRECTING CLASSES AND ACTING CLASSES

Scenework is an important part of both acting classes and directing classes. The exercises outlined above will be useful for both actors and directors.

When scenework is done in acting classes, it is generally done with the instructor functioning as director and assigning exercises based on where they believe the actors to be in their training. Nonetheless, some actors may find some of these exercises worthwhile to do with their scene partners while rehearsing outside of class. There are many professional actors who find some exercises so helpful that they do them throughout their entire careers.

When scenework is done in a directing class, the directors are usually working with actors under the supervision of an instructor. The instructor should help directors work with the actors based on their level of training. In all cases, a performance should be changed incrementally with small adjustments and lots of positive reinforcement to the actors about what is working well.

An instructor may suggest specific exercises to the director to try with the actors, or the director may have more latitude in working with the actors. Regardless, care should be put into the selection of exercises. It is the job of the director or instructor to identify the strengths and weaknesses of a performance and find the right techniques to address these issues. This skill will have to be built through observation and trial and error. Trying some of the exercises described above can be a good start.

AUDITION WORKSHOPS

Scenework is most often done as practice for finished performances in film or on stage, but it can also be used to practice for auditioning. So much of an actor's success depends on

their ability to audition successfully—and so much of a production's success depends on how well it is cast—that practicing auditioning is extremely valuable.

The short scenes in this book are particularly useful for audition workshops since audition sides are rarely longer than two pages. Auditions differ in the amount of prep time allowed. In an audition workshop, the scenes can be prepped by the actors ahead of time, but it is also a good exercise to attempt the scenes with little or no prep, having the actors perform what is called a cold read. This happens at auditions in the professional world, but is also a useful exercise to help actors make strong choices quickly.

In a cold read exercise, it is important to not let reading the script interfere with listening, processing, and responding believably. Actors should practice the habit of checking their next line in the script immediately after delivering their line because this is when the audience's attention will have shifted to the other actor in the scene. Actors should have their attention back to the other actor before that actor has finished their line, so as to be focused during the most important moment of their performance: their reaction.

In all auditioning, it is important for actors to make strong choices that highlight their individual strengths and differentiate them from other auditioners. No one exercise will help actors identify their strengths, as this generally only comes with experimentation and experience. An exercise that can provide feedback on whether actors are making bold and unique choices is to make all the actors in a class cold read the same side and then ask the class what aspects of which performances stood out. A variation on this is to ask at the next class meeting which of the performances stayed in people's heads. Care should be taken with this exercise not to encourage choices that are off-putting or seem desperate. Actors should always make strong, clear choices that are appropriate to the material. They will differentiate themselves not by being outlandish, but by bringing their own unique strengths and personality to their work, especially their auditions.

Directors practicing auditioning should use exercises to help them embrace auditioning as a place to explore and play. Whether an actor is appropriate for a part can be gauged relatively quickly. It is more difficult and takes more practice to judge what an actor will be like to work with. Exercises can help directors gauge the flexibility and responsiveness of an actor to direction.

Directors can intentionally ask an actor to perform a scene in a way that is very different from their initial interpretation. This may be a change in style, objective, or physicalization as described in previous exercises, but the object is to push the actor out of their comfort zone and see how they respond. "As ifs" are particularly good ways to challenge actors and gauge how well they take direction. In an actual audition the director may not want to push an actor too hard, but in an exercise, it will help them learn. Trying different approaches with actors in an audition also helps the director to explore the potential of the material.

SUMMARY

Creating truthful, dramatic behavior under imaginary circumstances is the essential job of actors and directors. It is deceptively difficult to master. Actors and directors will develop most quickly by concentrating on their learning process and putting it ahead of achieving a result. They need to put their best effort in all their work, take risks, be open to feedback, and work at focused, incremental growth.

They also need to maintain a positive attitude and should be careful not to put undue pressure on themselves while they are learning. They are undertaking a long process in a difficult business. If they can't make this journey fun for themselves, it will simply not be worth it.

Above all, aspiring actors and directors need as much experience as they can get and need to make sure as much of that experience as possible is focused simply and squarely on creating compelling performances.

Scenework is the ideal vehicle for this process and the scenes in this book and the exercises above should prove particularly useful. Good luck!

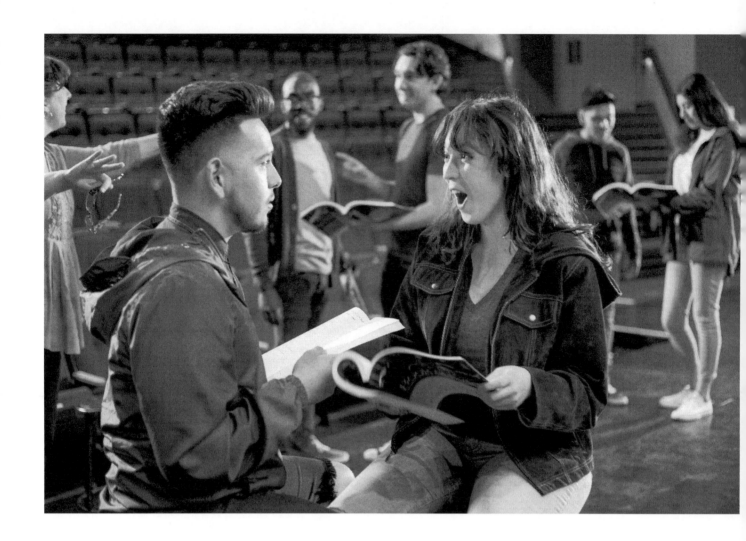

Bailey and Cletus sit side-by-side, both looking confused.

> BAILEY
> Something weird's going on here.

Cletus nods slowly in agreement.

> BAILEY
> Like things don't seem real.

> CLETUS
> Like being in a movie or something.

> BAILEY
> Or even weirder, like being in a dream.

> CLETUS
> Yeah.

> BAILEY
> So what's going on?

> CLETUS
> Are we on drugs?

They look at each other.

> BAILEY
> I don't think so. Do you remember taking
> drugs?

Cletus struggles to remember.

> CLETUS
> I don't remember a lot.

> BAILEY
> Me neither.

> CLETUS
> Are we dreaming?

> BAILEY
> How could we both be dreaming?

> CLETUS
> Right. Maybe it's just me dreaming.

> BAILEY
> I'm not just a part of your dream.

Cletus has to think about this one.

 CLETUS
 Isn't that what you would say if you
 were just part of my dream?

 BAILEY
 Uh... No?

 CLETUS
 Virtual reality?

They both look all around, then look at each other, shaking
their heads "no."

 BAILEY
 Government experiment?

 CLETUS
 Whoa, like MK-Ultra?

 BAILEY
 I never saw that. Was it good?

 CLETUS
 No, it, like, actually happened. MK-
 Ultra was a government experiment where
 they drugged people to find out about
 mind control.

 BAILEY
 That seems uncool. I was thinking more
 like Bourne Identity.

 CLETUS
 Yes!

Cletus starts throwing punches and karate chops in the air,
seeming to defeat a multitude of enemies.

 BAILEY
 Wait... I'm thinking now I do remember
 taking drugs.

 CLETUS
 Really? That seems kind of disappointing
 now.

 BAILEY
 Maybe the government put that memory in
 my mind, though.

They look at each other, smiling and nodding.

Simpson and Vondie walk till Simpson stops in a panic.

 SIMPSON
 My keys! What happened to my keys?!

 VONDIE
 You gave them to me, remember?

 SIMPSON
 Oh, right, of course. Hand 'em over.

 VONDIE
 You gave them to me for a *reason*.

 SIMPSON
 Don't be like that. I had like *one*
 drink.

 VONDIE
 You definitely had more than one drink,
 so now you pretty much have no
 credibility.

 SIMPSON
 What?! Stop messin'. I'm good. Gimme
 my keys.

 VONDIE
 Yeah, I don't think that's a good idea.

 SIMPSON
 I don't think it matters what you *think*.
 They're my keys and it's my car.

 VONDIE
 It mattered what I thought when you gave
 me the keys.

 SIMPSON
 Whatever. I'm not drunk. Just give me
 my keys.

 VONDIE
 Are you *buzzed*?

 SIMPSON
 What does that even mean?

 VONDIE
 Do you feel different than *normal*?
 Happier? *Looser*? Impaired judgment?

Simpson takes way too long to weigh this out.

> VONDIE
> How about if I drive you?

> SIMPSON
> How about if you mind your own business?

> VONDIE
> Okay.

Vondie begins to walk off.

> SIMPSON
> *Hey!* My keys!

> VONDIE
> Fine, here.

Vondie turns and tosses a small key ring. Simpson misses the catch, but picks the keys up off the ground, examining them.

> SIMPSON
> Hey, the *car* keys too. I'm not asking
> you to go with me. It's *my* car. How is
> this your problem?

> VONDIE
> What about the other people out *there?*
> The other *drivers?* People trying to
> cross the street?

> SIMPSON
> So you're the big hero, protecting the
> common folk?

> VONDIE
> No. You got me. I don't actually care
> about them at all.

> SIMPSON
> Ah ha!

> VONDIE
> It's *you* I care about. I love you and I
> won't let you do something stupid.

> SIMPSON
> You love *me?* I don't know what to say...
> I love you too. I do. I really do.

> VONDIE
> You *are* buzzed.

Flynn limps in, trying to sneak past Canton unnoticed.

 CANTON
 Are you okay?

 FLYNN
 Yeah, fine.

 CANTON
 Hold up. You don't look fine.

 FLYNN
 It's nothing.

 CANTON
 Did you hurt yourself?

 FLYNN
 Yeah... but I'll be fine.

 CANTON
 Is that *blood*? Are you... *shot*?

 FLYNN
 It's just a nick, but I need to clean it
 up and change.

 CANTON
 How did you get shot?!

 FLYNN
 Look you can't know anything about any
 of this, so just imagine you didn't see
 me and go back to what you were doing.

 CANTON
 That's not how it works.

 FLYNN
 How *what* works?

 CANTON
 How loving someone works. You're hurt.
 I *need* to help you, I have to make sure
 you're not in trouble.

 FLYNN
 I am in trouble and I can't be getting
 you into it, so just let me do my thing.

 CANTON
 Let me help you.

 FLYNN
Stay out of this. I don't want you in
this mess too.

 CANTON
Is that just a convenient way to get me
to back off?

Flynn sighs.

 FLYNN
I know I deserve that and I really
deserve a great big lecture from you if
I make it out of all this.

 CANTON
If?

 FLYNN
I'm leveling with you here. I'm in it
deep, real deep, and it might not end
well for me, but things are in motion
now that could make it all good.

 CANTON
This is crazy.

 FLYNN
No doubt.

 CANTON
I'll help you, whatever it takes. If I
need to use a gun, I will.

 FLYNN
Now it's you that's crazy.

Canton hugs Flynn.

 CANTON
I just... can't lose you.

 FLYNN
You won't if I'm sharp out there.

 CANTON
Be sharp out there, then.

Canton lets Flynn go. They look each other in the eye and Flynn
nods, heading out.

North walks in and sees Ray pocketing something.

> NORTH
> Did you just take that?

> RAY
> You mean did I *steal* that?

> NORTH
> Well... yeah.

> RAY
> What if I did?

> NORTH
> I mean... that's not cool.

> RAY
> Think of it as a bonus, not like they
> pay us anywhere near enough here.

> NORTH
> That doesn't make it right.

> RAY
> Makes it right enough for me.

Ray starts to go, but North gets in the way.

> NORTH
> Doesn't make it *legal* then.

> RAY
> Only a problem if you turn me in. Is
> that what this is?

> NORTH
> No, I'm not like *that*. I just don't
> want you stealing.

> RAY
> It's very sweet that you're *so* concerned
> for me, but really, I can make these
> kinds of decisions for myself.

> NORTH
> But it's not about you. At some point
> what's missing is going to be noticed
> and they're going to look around and say
> who took this and I *do not* want them
> looking at me.

 RAY
 Well, that's a fair point.

 NORTH
 Thank you.

 RAY
 But I'd say if you're going to end up a
 suspect anyway, you ought to at least do
 the crime.

 NORTH
 So I should start stealing too?

 RAY
 At least you'd end up with something to
 show for your trouble.

 NORTH
 Do you not realize what a messed up
 attitude that is? Maybe I should turn
 you in.

 RAY
 Okay.

 NORTH
 Okay? You're okay with that?

 RAY
 What can I do? That's on you if you're
 that type of person.

 NORTH
 No! No! It's on you if you're the type
 of person who steals.

 RAY
 I guess we agree to disagree on that.

Ray starts to leave again.

 NORTH
 I... well... I am a better person than you!

Ray stops for a moment.

 RAY
 Congratulations?

Ray leaves North fuming.

Wrigley wakes up next to Sean and clearly regrets it. Wrigley
tries to slip away, but Sean wakes up.

> SEAN
> Oh, hey.

> WRIGLEY
> Hey.

> SEAN
> You leaving? How about breakfast?

> WRIGLEY
> Can't, got stuff.

> SEAN
> ...Blueberry pancakes!

> WRIGLEY
> Thanks, but for real, I'm busy.

> SEAN
> Everything okay?

Wrigley thinks a moment before responding.

> WRIGLEY
> Not exactly. What is this? Aren't we
> broken up?

> SEAN
> Yeah, but why rush it?

> WRIGLEY
> Is that supposed to be funny? Seriously,
> what is *this*?

> SEAN
> I don't know... transitioning?

> WRIGLEY
> It doesn't seem right. We should either
> be broken up or not.

> SEAN
> I didn't plan on even seeing you. It
> just happened.

> WRIGLEY
> What were you doing so close to my work
> anyway?

 SEAN
 I told you, I had to pick something up
 at the hardware store.

 WRIGLEY
 What?

Sean hesitates too long.

 WRIGLEY
 That's what I thought.

 SEAN
 Okay, so maybe I missed you and was
 hoping to see you, but I didn't plan for
 all this to happen.

 WRIGLEY
 What *did* you want to happen?

 SEAN
 Stop acting like I tricked you or
 something. You didn't question the
 hardware store thing last night. You
 were *happy* to see me.

Wrigley considers a long moment.

 WRIGLEY
 I... was. I know I was. I miss you too,
 but I'm just not sure *this* is helping.

 SEAN
 We had our issues, but it's hard to let
 go of all the good stuff.

 WRIGLEY
 No doubt.

 SEAN
 So...

Wrigley considers a long moment.

 WRIGLEY
 I don't know... Blueberry pancakes?

 SEAN
 Blueberry pancakes!

 WRIGLEY
 I suppose there's no point in rushing.

Reno walks in pretending to carry something. Smith looks up and
watches as Reno sets the imaginary object down in front of them
with a flourish.

> SMITH
> I'll bite, what is it?

> RENO
> It's a magic button. Just by pressing
> it, you can kill anyone in the world.

> SMITH
> Okay, that's creepy and scary.

> RENO
> Wait, I'm telling you that you can hit
> that button and kill a terrorist.

> SMITH
> I don't know.

> RENO
> He won't suffer, but if you don't hit
> that button right now, he'll detonate a
> bomb in a crowded market... full of *kids*.

Smith reluctantly hits the button and then Reno hits it too.

> RENO
> Bam! Not so hard. Felt kind of good,
> right? Alright, now if you hit it, you
> can get rid of... an arms dealer.

Smith hesitates.

> RENO
> Lives in a mansion while kids get their
> legs blown off by his landmines.

Smith hits the button and then Reno does.

> SMITH
> Oh, he didn't suffer did he?

> RENO
> Bam! He never felt a thing.

> SMITH
> Okay, you can hit that button and take
> out a guy who kills lions and stuff.

Reno hits the button.

Bam!

12

 RENO
 Bam! Easy one for me. You can hit that
 button and take out a serial killer.

Smith hits the button and then Reno does.

 RENO
 Bam! Making the world a better place.

 SMITH
 War criminal.

Smith and Reno hit the button together.

 SMITH
 Hitler.

 RENO
 Hitler's already dead.

 SMITH
 C'mon, is the button *magic* or not?

Reno shrugs, smiles, and hits the button. Then Reno takes a
deep breath and looks into Smith's eyes.

 RENO
 The bastard who attacked *you*.

All the humor drains out of Smith.

 SMITH
 Is that what this was about all along?

 RENO
 Kind of... but I really do need to know
 where you stand on this.

Reno has hit a very sore spot and Smith can't even make eye
contact.

 RENO
 ...Because if you don't hit that button,
 then... I've done something terrible
 that you're going to have a problem with.

Smith looks up, eyes wide. Reno nods somberly. Smith looks at
Reno a long moment then reaches out and hits the button. Reno
sighs, relieved.

 RENO
 Bam.

Charlie approaches Reece

 CHARLIE
Hey, mind if I sit?

 REECE
Uh... Do I know you?

 CHARLIE
You will if we can be real a minute.

Charlie sits.

 REECE
Sorry, what?

 CHARLIE
I'm Charlie. You are?

 REECE
Are you kidding me? Did somebody put
you up to this?

 CHARLIE
What? Your name a secret?

Reece considers a long moment.

 REECE
Reece.

 CHARLIE
Reece? Cool name. I like it, so what
you do?

 REECE
You know, I'm here with some friends.

 CHARLIE
I got you covered till they get back.

 REECE
What if I prefer to wait alone?

 CHARLIE
You won't after we get to know each
other.

 REECE
Seriously, I appreciate the confidence
or persistence or whatever, but—

 CHARLIE
 ...Leave you alone.

 REECE
 Yes.

 CHARLIE
 Okay. I wasn't trying to make you
 uncomfortable or anything. I just
 thought maybe we could *chat*. No harm
 in talking I thought, but my bad.

Charlie starts to leave. Reece softens.

 REECE
 It's nothing like that. I just
 seriously wanted a quiet moment.

 CHARLIE
 You got it now.

 REECE
 Wait.

 CHARLIE
 What?

 REECE
 I don't know. Want to sit down for a
 minute?

 CHARLIE
 Won't your friends be back?

 REECE
 Yeah. I'm not here with friends. I
 just said that. Sorry.

 CHARLIE
 So we gonna be real now?

 REECE
 I guess...

 CHARLIE
 Good. I think you're gorgeous.

Reece is taken aback, but finally cracks a smile.

 REECE
 Okay, maybe we just don't need to be
 quite so real, quite so fast.

Auggie walks in holding a piece of paper.

> AUGGIE
> What's with this set list?!

> DELANEY
> I told you this was a big gig for us and could lead to a lot more work.

> AUGGIE
> More work playing nothing but covers.

> DELANEY
> We need the work.

> AUGGIE
> Work? I did not get into this for the money, did you?!

> DELANEY
> Well, no, but I have Bobby now.

> AUGGIE
> I get that, Del, but why does that mean I can't play anything I've written?

> DELANEY
> One show, *okay?* And then we'll work your stuff back into the set.

> AUGGIE
> Hah! I'm already down to four *songs*. Originals used to be half our *set*. We don't even play your stuff anymore.

> DELANEY
> My stuff is crap, okay? I liked writing songs, but I just wasn't that good at it. I've accepted that.

> AUGGIE
> So is my stuff crap, too? Are you telling me to accept that?

> DELANEY
> You're a better songwriter than me, you know that...

> AUGGIE
> But...

DELANEY
...But you're not better than the covers.

Auggie sinks to the ground.

AUGGIE
Wow. So this is it, the moment where I
realize I suck and my dream was a joke?

DELANEY
Getting people to dance is no joke. It's
special. It's a gift. You're a great
singer Auggie.

AUGGIE
Just somebody else's song, huh?

DELANEY
For one night.

AUGGIE
How long have you known?

DELANEY
What?

AUGGIE
That all we'll ever be is a cover band?

DELANEY
I do the *bookings*. I collect our *pay*.
You get a different perspective when you
deal with the club owners.

AUGGIE
A realistic perspective, you mean. And
you're okay with it?

DELANEY
I always looked at it differently. It's
all entertainment whether it's playing
originals in stadiums or playing covers
in bars—just let the people forget their
troubles three minutes at a time. Beats
digging ditches, don't it?

AUGGIE
That's beautiful. Put music to that.

Delaney offers a hand up to Auggie. Auggie looks at the hand
a long moment, and finally takes it.

C.C. enters and finds Radisson getting ready to leave.

> C.C.
> Oh, right, going to see the *folks!* Is
> Alex going with you?

> RADISSON
> Oh, no.

> C.C.
> "Oh, no" in that you don't want Alex
> meeting your parents?

> RADISSON
> Yeah, basically.

Radisson tries to hustle to get out.

> C.C.
> Wait... Do your parents know you're gay?

Radisson stops and takes a deep breath.

> RADISSON
> No, I never told them.

> C.C.
> C'mon, what's up with *that?* It's not
> like the old days. I'm sure they'd be
> fine with it.

> RADISSON
> I'm just not up to dealing with that.

> C.C.
> You're just imagining it's going to be
> worse than it probably will be.

> RADISSON
> Maybe, but I don't want to find out.

> C.C.
> You realize this not just about *you.*
> Coming out is about you fully accepting
> your identity, but coming out is also
> about all gay people standing up and
> saying it's okay for us all to be gay.

> RADISSON
> Sorry I'm bringing down the cause.

 C.C.
Don't shine me on.

 RADISSON
I know this political stuff is important
to you, but it's my life and my
decision.

 C.C.
There was a time not so long ago when
nobody came out and so everyone had to
deny who they really were and live in
shame. Think of how much harder it was
for anyone to come out then.

 RADISSON
Yeah, it's so easy for me now.

 C.C.
I know it's still hard, but if you don't
come out, you just make it harder for
those after you.

 RADISSON
That's just not the way I think.

 C.C.
What about Alex?

 RADISSON
What do you mean?

 C.C.
I never met Lee's parents. It destroyed
me. I felt like Lee was ashamed of me, and
then at the *funeral*... I couldn't even
say anything to them. It was the most...
awkward... painful thing.

This sinks on Radisson a long moment.

 RADISSON
Yeah. I made up a big story so Alex
didn't know where I was going this
weekend.

 C.C.
Forget everything about the next
generation and all that. Do you love
Alex, or not?

Radisson nods "yes" and shares a hug with C.C.

Lou is drawing furiously at a desk. Bennet walks in, examining
Lou and looking around.

 BENNET
Looks like you've been busy.

Lou doesn't look up from drawing.

 LOU
Hey, Bennet.

 BENNET
Nobody's seen you in a while.

 LOU
I get out. I have to eat.

 BENNET
Yeah, but what I'm saying is that people
are worried about you.

 LOU
I'm doing fine.

 BENNET
Are you doing *fine* with anything other
than your art?

 LOU
What else matters?

 BENNET
Yeah, that's why I'm here. We're kind
of worried you've lost perspective.

 LOU
So what, is this an *art* intervention?

 BENNET
I don't know what to call it, but you
used to have a life, a *whole* life with
friends and dates and family.

 LOU
I will again, but I'm not feeling any of
that right now.

 BENNET
Can you stop drawing for a second and
talk to me?

Lou looks up from drawing for the first time.

> BENNET
> There are people who care about you,
> people who are worried about you.

> LOU
> Because I'm spending a lot of time on my
> art?

> BENNET
> Because you're spending *all* your time on
> your *art*. People need balance. People
> go crazy this way.

> LOU
> Crazy like Van Gogh?

> BENNET
> Well, *yes*. Things didn't end well for
> him, you know that?

> LOU
> Didn't *they*? Van Gogh is pretty much
> synonymous with genius artist now. How
> is that not ending well?

> BENNET
> The man went nuts. He cut off his
> frickin' ear!

> LOU
> Yeah, but *Starry Night*...

> BENNET
> So, you think you're Van Gogh?

> LOU
> C'mon. I ain't crazy like that, but
> that kind of focus, that kind of
> commitment, that's what I'm about right
> now.

> BENNET
> How about lunch at *least*? We'll get out
> for a little while. I miss you.

> LOU
> I already ate. Come back sometime,
> though, I'll have something to show you.

Lou has returned to drawing. Bennet waits, but might as well
not be there. Bennet realizes, sighs deeply, and leaves.

Holland and Katsumi sit across from each other.

> HOLLAND
> I think this was a mistake.

> KATSUMI
> I thought it was nice.

> HOLLAND
> Yeah, it was, it was really nice
> actually, but I mean it's a mistake in
> the sense that it's... *encouraging* you.

> KATSUMI
> We got a bite together, what's the big
> deal?

> HOLLAND
> But this doesn't change anything, you
> understand that?

> KATSUMI
> What was this supposed to change?

> HOLLAND
> I don't want you to think this was a
> date or something and that I am secretly
> interested in something more with you.

> KATSUMI
> You know, you don't need to treat me
> like a crazy stalker. I am aware that
> I like you more than you like *me*. You
> don't need to keep reminding me.

> HOLLAND
> I didn't mean to—I'm worried about you,
> I really *am*. I don't want to hurt your
> *feelings*. You understand?

> KATSUMI
> Of course, but don't worry. I'm fine.

> HOLLAND
> Maybe, but I'll feel better when you're
> in a *real* relationship.

> KATSUMI
> I'm sure I will too.

> HOLLAND
> ...but not with me.

 KATSUMI
Would you mind not rubbing my face in
this constantly.

 HOLLAND
Sorry.

 KATSUMI
Look if you're not comfortable with
this, maybe I should stay away from you.

 HOLLAND
Is that what you want?

 KATSUMI
I would prefer to... well... you know,
but if you're having trouble—and you
clearly are—maybe *you* need some space.

 HOLLAND
Wow. Okay.

 KATSUMI
You alright with this?

 HOLLAND
Well... I'm a little disappointed. I
thought you liked me more than that.

 KATSUMI
I thought you didn't want me to like you
in that way?

 HOLLAND
Right...

 KATSUMI
Okay, now you are legitimately confusing
me with these signals.

 HOLLAND
I guess... I kind of want to see you.

 KATSUMI
...But not a date.

 HOLLAND
I don't know, maybe a date... or
something.

Holland smiles and Katsumi's shock quickly turns to a smile
too.

Cat enters and approaches D.D., who is sitting.

> CAT
> Hi.

> D.D.
> Oh, hi!

> CAT
> Should I... sit down?

> D.D.
> Yeah, of course.

> CAT
> I didn't know... I mean, I can still leave
> if, you know... you're disappointed.

> D.D.
> Disappointed with you? I don't even know
> you *yet*. Sit, please.

Cat sits across from D.D.

> D.D.
> So... not much of an internet dater?

> CAT
> No... *no*. This is my first time.

> D.D.
> It's not as weird as it seems at *first*.
> Try to relax into it.

> CAT
> Yeah. I'm trying.

> D.D.
> It's not that different from regular
> dating, just with more awkward silences.

> CAT
> I'm sure that's funny, but I'm not much
> of a dater at all, so the frame of
> reference is kind of lost on me.

> D.D.
> Oh.

On cue, there is an awkward silence.

 D.D.
 Any reason you don't date?

 CAT
 I... I just get irrationally nervous.

 D.D.
 I'm *sorry*. How did you...? I mean, if
 you're so anxious about all this, how
 did this date even happen?

 CAT
 Well, I... guess... I got matches before,
 but I never see anything important in
 common. It all seems... superficial.

 D.D.
 Then why me?

 CAT
 I saw in your profile about the... well...
 your parents being, you know...

 D.D.
 Oh. That's why? I mean, are your
 parents...?

Cat nods "yes" sadly.

 D.D.
 Sorry, Oh God, I'm so sorry. I know what
 it's like... of course...

D.D gets too choked up to speak.

 CAT
 I'm sorry. I'm really bad at this. I
 know dates aren't supposed to be sad.

 D.D.
 No, they're not.

 CAT
 Yeah, well... I'll just go.

Cat starts to get up, but D.D. gets up too and hugs Cat.

 CAT
 Dating is weird.

D.D. just hugs Cat tighter, and Cat finally relaxes a little
and hugs D.D. back.

Sydney enters, surprising Watson. Both are awkward.

> WATSON
> Yo, Syd. What's up?

> SYDNEY
> "What's up?" Do you realize how long
> it's been since I've seen you?

> WATSON
> Been a minute, but I didn't want to make
> a big thing of it. You know...

> SYDNEY
> No, I don't know.

> WATSON
> Things change. People change. Move on
> and all that.

> SYDNEY
> I'm the same. How have you changed?

> WATSON
> Maybe not me so much. We're just into...
> different *scenes now*. You know...

> SYDNEY
> No, *I don't know*. What's your scene now?

> WATSON
> What's with all the questions? What is
> this?

> SYDNEY
> I care about you. You *know* that, right?

Watson shrugs.

> SYDNEY
> Then we can talk, right? You can tell me
> what's going on, right?

> WATSON
> Sure, but everything's good, real good.

> SYDNEY
> Oh *yeah?* Because I think you've got a
> *problem*. I know you *do*. Let me help.

> WATSON
> Is that what this *is*? Syd to the rescue?

> SYDNEY
> It's not about me.

> WATSON
> You *sure*? It usually is.

Sydney is taken aback.

> SYDNEY
> Okay. Maybe I deserve that.

> WATSON
> Never miss an opportunity to judge—
> anything to feel superior.

> SYDNEY
> Is that what you think of me?

> WATSON
> I thought this wasn't about you?

Watson gloats, but Sydney regroups.

> SYDNEY
> It's *not*. You're *clever*. You're trying
> to put me off, but I don't *care*. You
> need *help*. I'm going to help you.

> WATSON
> Don't I need to want *help*? Isn't it only
> me that can help me or some crap?

> SYDNEY
> I can see that you're hurting. You
> really don't want help?

Watson starts to break down, but turns away.

> WATSON
> Not from *you*. Never from you.

It sinks in on Sydney.

> SYDNEY
> I'm sorry, I guess. Sorry mostly that I
> can't help.

Sydney backs out and Watson never turns back around.

Stacey walks in.

> STACEY
> Do you have any money?

T.T. looks up angry.

> T.T.
> Not for you, I don't.

> STACEY
> Wow. Why the attitude?

> T.T.
> *Seriously?* All you ever do is hit me up
> for money.

> STACEY
> You can always say *"no."* It's not like
> I'm trying to rob you or *something.* Why
> do you have to get angry?

> T.T.
> Because you do it all the time. Am I an
> ATM to you?

> STACEY
> Clearly not, or you'd actually give out
> money.

> T.T.
> Not funny.

> STACEY
> That's exactly what I'm talking *about.*
> Where's your sense of *humor?* We used to
> have fun.

> T.T.
> Yeah, before I realized you were only
> after my money.

> STACEY
> I'm happy just to be here with you. I
> don't care if you give me money or not.

Stacey plops down, smiling at T.T. T.T. sighs.

> T.T.
> I'm not going to give you money just to
> get rid of you.

 STACEY
You want to get rid of *me?* Is this what
things have come to with us?

 T.T.
Okay, let's have a visit then. Tell me
about something that doesn't have to do
with money.

 STACEY
Hmmm... Remember the time we set off all
those fireworks behind the church and one
landed on the roof?

 T.T.
That hundred or so dollars worth of
fireworks that you talked me into
buying?

 STACEY
Oh, c'mon, is that all you remember
about *that?* I remember having an amazing
time. We laughed *so* hard.

T.T. softens a little.

 T.T.
It was fun. My sides hurt afterward.

 STACEY
Right?

 T.T.
We are friends. I'm sorry I was mean.

T.T. pulls out money and offers it to Stacey.

 STACEY
No. I see it's come between us.

But T.T. just continues to hold out the money.

 STACEY
Your friendship means more to me.

T.T. just holds out the money.

 STACEY
I suppose this one time couldn't *hurt.*
Thanks! You're the best.

Stacey grabs the money and runs out. T.T. sighs deeply.

G.G. enters and begins scrutinizing Cori, making Cori uncomfortable.

 G.G.
Hi.

 CORI
Uh, hi...

 G.G.
Can I talk to you? I mean, maybe I'm not the one to talk to you—and it's none of my business and all that—but I've seen you—and I've noticed... well, let me put it this way. I used to... well there was a time that I was... being abused...

Cori looks ready to leave.

 G.G.
Just let me *finish*. It'll only take a minute and then I won't ever bother you again if you don't want—see I was being abused and it just didn't seem like it to me at the *time*. It seems crazy to me now, but I was so good at coming up with reasons and rationales. I had an answer for everything, a million reasons why I either deserved it or I wasn't really being abused at all.

 CORI
Why are you telling me all this?

 G.G.
Do you know how hard this is to talk about?

 CORI
I didn't ask you to tell me all this.

 G.G.
I know, but I wanted *to*. I wanted you to know you're not alone.

 CORI
I barely know you.

 G.G.
Yes and *no*. I do know exactly what you're going through.

 CORI
I don't think you do.

 G.G.
I never wanted to admit anything either,
but it'll only get worse if you don't
acknowledge it, believe me.

 CORI
I don't get you. Why are you doing this?

 G.G.
Nobody ever talked to me. Nobody showed
me a way out.

 CORI
That's terrible—I don't know what it's
got to do with me—but I'm glad things are
better for you now.

G.G. looks down, ashamed.

 G.G.
They're not.

 CORI
What?

 G.G.
I... I said all that... like it was in
the past, but I actually haven't done
anything.

 CORI
So this is all just you wanting to talk
to someone about *your own problems*? It
isn't about me at all?

 G.G.
It doesn't have to *be*. It could be about
us. Us listening to each other and maybe
helping each other.

G.G. extends a hand, but Cori only looks at it.

 CORI
Sorry, sincerely, but it sounds like you
need somebody who's got the same kind of
problems you got.

Cori walks out, leaving G.G. crushed.

Ali staggers in looking sick.

 ALI
 I feel like crap.

 SAWYER
 You look terrible. Are you gonna puke?

 ALI
 Maybe, I don't know.

 SAWYER
 Don't be sick in here.

 ALI
 What? That's all you're worried about?

 SAWYER
 Well, yeah, I'm sorry you feel bad and
 all that, but seriously, don't be sick
 in here.

 ALI
 I'm dying here.

 SAWYER
 A little dramatic, but don't die in here
 either.

 ALI
 It's not funny. I think maybe I should
 go to a doctor or a hospital.

 SAWYER
 Okay, can I call you a ride or
 something?

 ALI
 Wow. Don't put yourself out.

 SAWYER
 It's not that, I just have a date coming
 over.

 ALI
 Really?

 SAWYER
 You know, you do look *bad*. Seriously,
 let me call you that ride.

 ALI
 Wait. Who?

 SAWYER
 The date?

 ALI
 Yes, who is the date with?

 SAWYER
 Sandy.

 ALI
 Oh my God, I'm gonna puke all over this
 place.

 SAWYER
 That's not *cool.* It's not like you guys
 were seeing each other.

 ALI
 I know, but you knew how I felt, we
 talked about this.

 SAWYER
 I didn't plan it. It just happened.

 ALI
 Who asked who?

 SAWYER
 I... don't remember.

 ALI
 Such a *liar.* Blehh. I'm feeling worse.

Ali plops down.

 SAWYER
 I'm calling you a ride.

Ali just groans in what is clearly a show.

 SAWYER
 Alright, I'll drive you myself.

Ali groans louder, then the groaning changes suddenly from
fake to very real and Ali jumps up and runs out.

 SAWYER
 At least you weren't sick in here.

Becket bursts in on Easton.

 BECKET
You're cheating, I know it!

 EASTON
Cheating? Like on you?

 BECKET
Of course!

 EASTON
Don't be stupid.

 BECKET
Hah! Robbie saw you with Leighton.

 EASTON
You're going to piss me off with this.

 BECKET
So you weren't with Leighton?

 EASTON
At Starbucks?

 BECKET
So you admit it?

 EASTON
I admit having coffee with Leighton. How
do you go from that to cheating?

 BECKET
It was Leighton! Everyone knows about
Leighton.

 EASTON
Everybody but me, apparently.

 BECKET
Leighton slept with Lee and Markie and
nearly broke up Chris and Kingsley too.

 EASTON
Wow. I have a lot more to talk to
Leighton about next time we have coffee.

 BECKET
You're going to see Leighton again?

 EASTON
For coffee, yes.

 BECKET
I can't believe you. Do you care at all
about me?

 EASTON
Don't be stupid. I'm the one that should
be mad.

 BECKET
Why?

 EASTON
You clearly don't trust me at all.

 BECKET
That's not true. I do trust you. I'm
just—

 EASTON
...Stupid.

 BECKET
I was going to say jealous.

 EASTON
That too. Now will you relax?

 BECKET
Sure. You're right.

Becket takes some deep breaths and seems to calm down.

 BECKET
So... what *did* you and Leighton talk
about?

 EASTON
We set up our next hook-up, of course.

Becket is shocked at first, then smiles.

 BECKET
Don't be stupid.

They share a laugh.

 EASTON
There's hope for you yet.

Smitty and Zion huddle in the dark, talking quietly.

> SMITTY
> Are we gonna die?

> ZION
> Don't talk like that.

> SMITTY
> Sorry.

They both stay quiet for a moment.

> SMITTY
> Do you think we're safe here?

> ZION
> Safe as anywhere.

> SMITTY
> We could run.

> ZION
> I think hiding's *better*. I think
> somebody will come get us once it's
> safe.

> SMITTY
> Unless we get found first by the—

> ZION
> Don't talk like that.

> SMITTY
> Sorry.

They both stay quiet for a moment.

> SMITTY
> Do you think it's someone we know... who's
> doing this?

> ZION
> I don't think that's a good subject to
> talk about either.

> SMITTY
> Obviously, I have no idea what to talk
> about, but I'm glad you're here.

 ZION
I'm glad you're here too. I wouldn't want
to be here alone.

 SMITTY
It's not just that... it's... I should
tell you something, in case, you know...

 ZION
Don't talk like that. We're going to be
fine.

 SMITTY
Do you know that for sure?

 ZION
No, but... I'm trying to be positive.

 SMITTY
Right. I always liked you.

 ZION
Was that the thing you wanted to tell
me? I like you too.

 SMITTY
No, I *like* you.

 ZION
Oh.

 SMITTY
Don't worry, I know already you don't
feel the *same*. I never would have said
anything except, you know...

 ZION
Yeah... Don't worry, I think it's *nice*.
It's a good thing to talk about.

 SMITTY
Really?

 ZION
Well I don't *mean*... Just—

 SMITTY
Yeah, well, at least I can say I told
you, if...

 ZION
Don't talk like that.

Alex and E.J. are sitting next to each other, stealing shy glances.

> ALEX
> You sure about this?

> E.J.
> Uh, yeah.

> ALEX
> Cool. I just, you know, wanted to make
> *sure*. It's important to... make *sure*...
> "Yes means yes" and all that—or is it "no
> means no"?

> E.J.
> Yes. And yes means yes.

E.J. smiles and Alex laughs weakly.

> E.J.
> So... what do we do?

> ALEX
> What do you mean?

> E.J.
> I'm new to this, so I'm going to need
> you to kind of... walk me through.

> ALEX
> *What?* Are you saying you've never...?

> E.J.
> Done *this*? No.

> ALEX
> Wow, well that complicates things.

> E.J.
> I'm a fast learner.

> ALEX
> I mean, like do you even know what
> you're getting into here?

> E.J.
> I think so. I've *seen* the internet.

> ALEX
> It's just that it's a much bigger thing
> for you now.

> E.J.
>
> I mean, it was, like, always a big thing for *me*. Does this change things for you or something?

> ALEX
>
> I suppose, it's like a bigger... responsibility for me now.

> E.J.
>
> *Oh?* Was this a casual thing to you before?

> ALEX
>
> I don't mean that. I just mean, now it's like...

> E.J.
>
> Like what?

> ALEX
>
> Harder to know... how you'll react.

> E.J.
>
> *Oh?* What are you afraid I'll do?

> ALEX
>
> I don't know... get attached.

> E.J.
>
> Oh. Would that be a bad *thing*? Isn't that kind of how this works sometimes, even if it's not someone's first time?

> ALEX
>
> Sometimes... yeah. I just don't think I want that.

> E.J.
>
> Ever?

> ALEX
>
> Not *ever*. I suppose... just not *now*.

> E.J.
>
> And... not with *me*.

Alex can't make eye contact.

> ALEX
>
> I'm sorry.

Slater approaches Neeho.

> SLATER
> Hey, hey!

> NEEHO
> Hey...

> SLATER
> What are you doing?

> NEEHO
> Reading.

> SLATER
> Cool. Feel like taking a break?

> NEEHO
> For what?

> SLATER
> I could use a ride.

> NEEHO
> Really?

> SLATER
> Good chance for us to catch up.

Neeho considers for too long a moment.

> SLATER
> Everything okay?

> NEEHO
> What am I to you?

> SLATER
> What do you mean? You're my friend—my
> good friend.

> NEEHO
> Am I?

> SLATER
> Of course. Is this because I asked you
> for a *ride*? Friends help each other out,
> don't they?

> NEEHO
> I don't do the rides and stuff for my
> other friends.

 SLATER
 ...Thanks?

 NEEHO
 Why do you think I do those things?

 SLATER
 I *thought* because we're friends...

 NEEHO
 We are friends, I'm not saying we're
 not, but being friends... is not enough.

Slater takes a moment to process this.

 SLATER
 Oh my God... Is this... like a friend-
 zone thing?

 NEEHO
 Please don't make it sound stupid.

 SLATER
 Stupid? I'm the stupid one. How did I
 not pick up on this?

 NEEHO
 I never said anything.

 SLATER
 So I've been taking advantage of your
 feelings for me all this time?

 NEEHO
 I don't know if I'd think about it *that*
 way.

 SLATER
 How else can I think about it?

 NEEHO
 You weren't taking advantage of me if
 you have any of the same feelings.

Slater freezes. Neeho waits anxiously for a response.

 SLATER
 Hey, *I*... I'm *so* sorry. I'll find
 another ride.

Slater leaves hastily. Neeho crumples to the ground.

Aalam approaches Dayton hesitantly.

> **AALAM**
> I need to talk to you.

> **DAYTON**
> Oh no... not *again*.

> **AALAM**
> Nice to see you too.

> **DAYTON**
> Can't you just let it go with us?

> **AALAM**
> It's not that... It's something important. Just give me a minute.

> **DAYTON**
> Okay, what is it?

Aalam searches for the words.

> **DAYTON**
> A minute, remember?

> **AALAM**
> I... I have herpes.

> **DAYTON**
> Oh my God, that's disgusting. So you finally got with someone else?

> **AALAM**
> No... It's not since we broke up.

> **DAYTON**
> What?

> **AALAM**
> *You* need to get tested.

> **DAYTON**
> Are you kidding! You mean... you may have given me an STD?

> **AALAM**
> You made me get checked before we... Don't you remember?

> **DAYTON**
> Then... you cheated on me?!

 AALAM
You know, I would never have...

 DAYTON
Well then... Wait, are you saying, it
was *me*?

 AALAM
No judgment. Just get tested.

 DAYTON
No *way*. I don't believe you. Why should
I believe *you*? This is just more of your
jilted-lover craziness.

 AALAM
Yes, I've been crazy.

Aalam is becoming emotional and tries to go.

 DAYTON
I do not have herpes.

 AALAM
Get tested and you'll know for sure.

 DAYTON
No way. I wouldn't give you the
satisfaction.

 AALAM
It's really not about me... or you, do it
for... whoever else... you're with.

 DAYTON
Oh, is this your chance to be righteous?

 AALAM
Whatever. I didn't come here for this.

Aalam starts to leave again.

 DAYTON
Whatever. I dumped you. I'm glad I
dumped *you*. I'm even more glad now. This
doesn't change anything.

 AALAM
It does change one thing, I think maybe
I'll be able to get over you now.

Aalam leaves and Dayton stews.

Denver enters and tries to wake Frances.

> DENVER
> Hey!

> FRANCES
> Shhhh...

> DENVER
> C'mon get up.

> FRANCES
> What?

> DENVER
> C'mon we need to go.

> FRANCES
> What time is it?

> DENVER
> Time to go.

Frances sits up.

> FRANCES
> What are you talking about? Where are we
> going?

> DENVER
> We're going to go to look for a job,
> remember?

> FRANCES
> You have a job, don't you?

> DENVER
> Okay, I'm going with *you* to look for a
> job. We talked about it last night.

> FRANCES
> Oh! I was *way* drunk last night...

> DENVER
> Yeah, I know, but we're still going
> through with this.

> FRANCES
> For sure, but... later. Right now I need
> to sleep. You get it.

Frances lies back down. Denver stares a moment before grabbing and shaking Frances.

> DENVER
> C'mon.

> FRANCES
> Stop! What's wrong with you?

> DENVER
> What's wrong with *you*? You used to have it together, now all you do is party all night and sleep all day.

> FRANCES
> Maybe you're *right*. I been at it pretty hard *lately*. I need to get it together.

> DENVER
> Thank you.

> FRANCES
> I look a mess though, just a little more sleep and I'll be presentable.

> DENVER
> You can sleep more if you want, but when you do get up, you can just leave and not come back.

> FRANCES
> You're throwing me out?

> DENVER
> Not if you get off your ass and go out to look for a job with me.

> FRANCES
> Harsh.

> DENVER
> Yes, I'm doing this because I hate you and want to punish you.

Frances is not sure how to take Denver. After a long moment, Frances breaks into a warm smile.

> FRANCES
> I think this may be the nicest thing anyone's done for me in a long time.

> DENVER
> Just get up.

Leslie walks in on Remy who is watching TV.

 LESLIE
 What is this crap?

 REMY
 Hmmm? It's one of my shows.

 LESLIE
 You don't really watch this.

 REMY
 I'm trying to.

 LESLIE
 Let's watch something together.

 REMY
 After this.

They both sit watching the TV for a long moment. Leslie's
displeasure building.

 LESLIE
 Gimme the remote.

 REMY
 What? No.

 LESLIE
 Give it to me.

 REMY
 Stop it. I'm watching my show.

 LESLIE
 It's *crap*. There's too much good stuff
 on TV to watch crap like this.

 REMY
 Go be a TV critic if you want to be
 "judgy." I like it, and I'm watching it.

 LESLIE
 Gimme the remote.

Leslie crowds Remy who hides the remote.

 LESLIE
 Only idiots watch this.

 REMY
 Only bullies have to always watch what
 they want.

Leslie backs off.

 LESLIE
 I thought you had taste.

 REMY
 I do, but it's *my* taste, not *your* taste.

 LESLIE
 Don't you have any pride? Don't you care
 what people think of you?

 REMY
 Am I supposed to not watch what I want
 to watch because of what people might
 think of me? What kind of "pride" would
 that be?

 LESLIE
 That was pretty good.

 REMY
 Thank you.

 LESLIE
 Now gimme the remote.

Leslie crowds Remy again. Then they both stop and look at the
TV a moment.

 REMY
 Great now it's over and I pretty much
 missed the whole end.

Remy disdainfully tosses the remote. Leslie catches it,
happily clicks through the channels and quickly finds
something pleasing.

 LESLIE
 So much better.

They both sit watching the TV for a long moment. Remy's
displeasure building.

 REMY
 Gimme the remote.

Duffy and Ell are saying goodbye.

> DUFFY
> Look, now that it's over, I want you to
> know that I don't believe in God.

> ELL
> You lied to me about believing in God?

> DUFFY
> Basically, it was kind of a white lie
> just to avoid trouble with you, but it
> never sat right with me and I wanted to
> get it off my chest.

> ELL
> You went to services with me.

> DUFFY
> In for a penny, in for a pound.

> ELL
> *Wow.* I don't know what to say. I'll
> pray for you.

> DUFFY
> Don't waste your time.

> ELL
> No need to get nasty now.

> DUFFY
> Why not? You know how much spiritual
> nonsense I had to nod along to?

> ELL
> Are you sure you're not just angry?

> DUFFY
> Oh, I'm completely rational. And I am
> telling you there is no rational
> argument for a God. Would God create
> people who kill each other, rape each
> other, rob each other, cheat each other,
> not to mention world wars and genocides?

> ELL
> Few fulfill their spiritual potential.

> DUFFY
> That's a poor showing for God, I guess.

 ELL
I don't know where you're coming from
with this.

 DUFFY
Not to mention all the terrible things
done directly in God's name: wars,
killings, oppression—especially of *women*.
What kind of God allows this?

 ELL
One that allows us flawed humans a hand
in our own affairs.

 DUFFY
See, you don't want to hear any of *this*.
Now you see why I avoided it.

 ELL
Frankly, it's a pointless argument to me
anyway, because I don't need a rational
explanation. I *feel* God.

 DUFFY
Did you feel God when you shattered your
leg? When your mom *died*? When you had
chicken pox?

 ELL
Those are just tests. I feel God when
I'm in nature.

 DUFFY
Nature?! Where the strong basically
consume the *weak*? That's your evidence
of the *divine*? Not a natural world where
kindness always defeats cruelty or
justice prevails, but a world where not
only do the strong prevail, but they eat,
eat the weak. If there were a God,
good people would always be rewarded,
the faithful would thrive, and you would
not have cheated on me!

Duffy seems to have not meant to say that last part and there
is an awkward pause.

 ELL
Ah... Well, I think I see where you're
coming from now, but maybe you should put
that on me, not God. Sorry.

Dawson approaches Tam, but is surprised when Tam turns around.

 TAM
 Dawson?

 DAWSON
 Oh, hey... Tam... how are you?

 TAM
 Dawson?!

 DAWSON
 Yeah... funny seeing you too.

 TAM
 Yeah... funny.

 DAWSON
 Haven't seen you in a while.

 TAM
 Are you gonna act like I don't know why
 you're here?

 DAWSON
 What do you mean?

 TAM
 C'mon...

 DAWSON
 What?

 TAM
 Look, I know you're here to meet me.
 I'm not ashamed, why are you ashamed?

 DAWSON
 I don't know what you're talking about.

 TAM
 Have it your way then.

 DAWSON
 It was great to see you.

 TAM
 You *too*. Too bad you don't want to
 score, though, cause I'm holding.

 DAWSON
 Score?

 TAM
 Please, did you not make a call and
 arrange this meeting?

 DAWSON
 No... not with you.

 TAM
 I'm what's called a runner.

 DAWSON
 Okay, fine. I've got the money.

 TAM
 First, tell me about perfect Dawson...
 out scoring on the street.

 DAWSON
 Do you want the money or not?

 TAM
 Seriously, don't you know what a
 superior attitude you always copped?

 DAWSON
 Hey, I'm not a *drug dealer*.

 TAM,
 Hey, I'm not a *user*.

 DAWSON
 You know, there's plenty of other places
 I could buy.

 TAM,
 Don't get worked up. Can't you
 appreciate how crazy it is for me to see
 you on my level?

 DAWSON
 Enjoy it then. Here.

Dawson hands Tam money and Tam hands Dawson a small package.

 TAM
 I will. It was *great* seeing you.

 DAWSON
 Great seeing you too.

Dawson leaves. Tam does a little dance.

Judson and Pembe channel surf.

> JUDSON
> Ooh, "Dr. Strangelove"! Let's watch it.

> PEMBE
> I don't know. What is it?

> JUDSON
> Are you *kidding*?! It's a classic—Stanley
> Kubrick—one of the greatest dark
> comedies of all time.

> PEMBE
> Is it in *color*? I'm not really into
> black-and-white movies.

> JUDSON
> *What?* Some of the greatest movies ever
> made are black-and-white.

> PEMBE
> I'm *sure*. They're just not my thing.

> JUDSON
> But it's not just a movie, it's history,
> it's *culture*. Watching a classic like
> this is like going to a museum.

> PEMBE
> Museums aren't exactly my thing either.

> JUDSON
> *What?!* How can you live? Are you part
> of the human race?!

> PEMBE
> Yes, you're the only one who knows
> what's good and what's bad and what's
> important and what isn't.

> JUDSON
> C'mon, it's more than *that*. Don't you
> want to understand the world? This movie
> is a window into the Cold War and the
> threat of nuclear annihilation.

> PEMBE
> Why do I care about that?

> JUDSON
> Okay. Do you read books?

PEMBE

Alright, you win. You're superior. Can
we move on and watch something else?

JUDSON

Seriously?

PEMBE

Being smart isn't everything. I know
when you're smart the way you are, it
seems like it is, but really, it's not.

JUDSON

Who doesn't want to be smart?

PEMBE

Who doesn't want to be beautiful? Who
doesn't want to be *athletic?* Who doesn't
want to be *popular?* You play the hand
you're dealt.

JUDSON

So... you *do* want to be smart?

PEMBE

Yes. It would be great to know all the
stuff you know and be able to appreciate
all that stuff, but that's not *me.* Is
that what you want to hear? Does that
make you feel *better?*

JUDSON

That's not what I was getting at.

PEMBE

Wasn't it?

JUDSON,

I'm just excited to turn people on to
great stuff they might not know about.

PEMBE

Excited for them or excited to show off
your broad knowledge and superior taste?

JUDSON

You know... you're not dumb.

PEMBE

Thanks. Now put something else on.

Carsey runs in, startling Afsar.

> AFSAR
> Jeez, what's wrong with you?

> CARSEY
> We need to get out of here.

> AFSAR
> We just got here. What's the problem?

> CARSEY
> Something's wrong, something's really
> wrong here.

> AFSAR
> It's not the nicest décor...

> CARSEY
> I'm not kidding, there's something weird
> here, like it's...

> AFSAR
> It's what?

> CARSEY
> ...Haunted.

> AFSAR
> Please. Are you kidding me? You watch
> too many movies.

> CARSEY
> You don't feel something?

> AFSAR
> It's cold right now. It'll warm up.

> CARSEY
> Listen.

They both listen for a moment and hear something.

> AFSAR
> Drafty.

> CARSEY
> *What?!* Is there really nowhere else for
> us to go?

> AFSAR
> Not *tonight*. If you still don't like it tomorrow, we'll look into another place.

> CARSEY
> If we're still alive tomorrow.

> AFSAR
> You're working yourself up. Ghosts don't kill people anyway, do they?

> CARSEY
> Depends on the movie.

> AFSAR
> Maybe these are friendly ghosts. There are friendly ghost movies aren't there?

Suddenly they both hear something.

> AFSAR
> What was that?

> CARSEY
> Right?

> AFSAR
> You've just wound me up.

> CARSEY
> What? You heard that!

> AFSAR
> All right, I'll have a look around.

Afsar starts to walk off, but Carsey grab's Afsar's arm.

> AFSAR
> You can come with.

Afsar starts to go again, but Carsey's grip is tight.

> AFSAR
> Are we gonna stand here all night?

> CARSEY
> No. We're gonna leave.

Suddenly they both hear something again. They share a look and back out of the room, still arm in arm.

Grayson walks in looking concerned. Hollister looks up.

 GRAYSON
He just called me Hollister.

 HOLLISTER
I know, right? He called me Grayson the
other day.

 GRAYSON
Yeah. It's getting worse.

 HOLLISTER
I'm getting more forgetful myself.

 GRAYSON
Seriously, we need to talk about what's
next for him.

 HOLLISTER
Do we?

 GRAYSON
At some point it's not safe for him to
be alone, maybe that's now.

 HOLLISTER
Please. He's fine. You know what his
independence means to him.

 GRAYSON
Yeah, but it's not just about what he
wants. He's our responsibility.

 HOLLISTER
Is he?

 GRAYSON
With everyone else gone, yes, I think
it's on us. Don't you want him to be
safe?

 HOLLISTER
Of course. Don't try to manipulate *me*.
He's just not ready for that and I'm not
going to let you pressure me into it.

 GRAYSON
What about the hose?

 HOLLISTER
So, the yard got wet...

 GRAYSON
 Flooded, but that was just a hose, what
 if it was the stove or the fireplace?

 HOLLISTER
 Jesus, you're morbid. He's more likely
 to walk outside without his pants or
 something. This is not a crisis.

 GRAYSON
 Shouldn't we do something before it is a
 crisis?

 HOLLISTER
 He's an adult who actually knows a lot
 more than either of us might ever know.
 If he wants to go into a home, that's his
 decision. We are not his parents.

 GRAYSON
 I understand your feeling, but if
 something happened to me and I was a
 danger to myself, I'd want you to do
 whatever was necessary to keep me safe.

 HOLLISTER
 He does not want to be in a home. I know
 the man. I've spent a lot of time with
 him, a lot more than you have.

 GRAYSON
 Just because you spend more time with
 him doesn't make you *right*. I think
 you've lost your objectivity.

 HOLLISTER
 Of course, you're the only one who can
 see things *clearly*. Isn't that always
 the case about everything?

 GRAYSON
 Right. I'm thinking now that this isn't
 about him at all.

Grayson leaves. Hollister thinks a long moment.

 HOLLISTER
 I... no... that's not true.

But Hollister is clearly shaken.

A.C. is looking at a painting. Wynn walks up and stands
shoulder to shoulder.

> WYNN
> The scale and all that red are obviously
> a cry for *attention*. It's too bad
> the draftsmanship and brushwork don't
> warrant that attention.

> A.C.
> Oh? You *think*? At least the artist had
> the guts to put something up on a *wall*.
> Easy to be a critic.

> WYNN
> Don't like critics?

> A.C.
> Not particularly.

> WYNN
> You want an audience here, though, don't
> *you*? If people can appreciate the art,
> why can't they criticize it too?

> A.C.
> That's pretty good, but it's specious,
> since appreciation is private, whereas
> criticism is an imposition of an
> individual's views on others.

Wynn seems to re-evaluate A.C. and becomes more playful, even
flirtatious.

> WYNN
> Okay, let me put it this way then, do
> you want all these people to share their
> praise when they like something or keep
> that to themselves as well?

> A.C.
> Why not try to appreciate what the
> artist was trying to do even if it
> doesn't connect with you personally?

> WYNN
> Believe it or not, I didn't come here
> hoping to see art I wouldn't like.

> A.C.
> Okay, but then why so negative?

 WYNN
 High standards?

 A.C.
 I wonder how much the quality of the art
 matters... or are you just always
 thinking about what you can say about it
 that sounds smart and impresses people?

 WYNN
 Ha ha! Did I really sound smart and
 impress you, though?

 A.C.
 A little.

 WYNN
 So which of these is yours?

Wynn gestures around at other paintings.

 A.C.
 You thought because I didn't like your
 criticisms, it must have been *personal?*
 I didn't paint this.

 WYNN
 I know. I did.

A.C. is shocked, but Wynn just shrugs.

 WYNN
 High standards.

A.C. looks at the painting again.

 A.C.
 You're too hard on *yourself.* The
 composition is good and there's
 absolutely nothing wrong with the
 brushwork. I like it.

 WYNN
 That doesn't say much about your taste
 and discernment.

Wynn starts to walk away.

 A.C.
 Wait, where are you going?

 WYNN
 High standards, remember?

Jordison walks in and sees Monroe acting sick.

> JORDISON
> Oh lord, what is it now?

> MONROE
> I don't *know*. My stomach is killing me:
> sharp pains like needles.

> JORDISON
> You had this one already, didn't you?

> MONROE
> Are you making fun of me?

> JORDISON
> I definitely remember this one. I think
> there were sweats with it, though.

> MONROE
> This is not funny.

Monroe grimaces and groans.

> JORDISON
> No, it's *not*. It's *tiresome*. It's
> *wearing*. It's just depressing.

> MONROE
> I'm sorry my poor health is so hard on
> you.

> JORDISON
> You're either the sickest person in the
> world or you're a hypochondriac. Which
> is it?

> MONROE
> I've been sick a few times, but I am not
> the sickest person in the world.

> JORDISON
> You're sick at least once a *week*. Last
> week it was a rash, and I think a bump
> too.

> MONROE
> Those were the same thing.

> JORDISON
> Week before that was the migraines,
> before that chills—

> MONROE
> I've had a bad run.

Monroe doubles over, wincing.

> JORDISON
> Well you should either give up this
> place and move into the hospital or go
> get some mental help.

> MONROE
> I already see a therapist.

> JORDISON
> *Really?* I didn't know... of course you
> seeing any *doctor* should not surprise
> *me.* They help you with the hypochondria?

> MONROE
> Hypochondriacs aren't actually sick. I
> don't think you understand that.

> JORDISON
> Right, right, but I am wondering if you
> fill in that therapist about all the
> latest maladies, the same way you do me.

> MONROE
> Of course. My therapist thinks I'm
> stressed and that's why I'm sick so
> often.

Monroe seems to be checking for fever.

> JORDISON
> *So...* Do they also think you're stressed
> because you're sick all the time?

> MONROE
> That's a good question. I'll ask her
> next time I see her.

Monroe winces again. Jordison sighs.

> JORDISON
> Also ask her if she thinks I'm stressed
> because you're sick all the time.

Jordison walks out, but Monroe is too distraught to notice.

Larson and Cagney are strolling together.

> CAGNEY
> This has been great!

> LARSON
> Yeah, I've had a great time too.

> CAGNEY
> Seriously. I want to do this again.

> LARSON
> Of *course*. Just say when.

> CAGNEY
> When!

They both laugh, but then fall into a small lull.

> LARSON
> I feel like telling you something.

> CAGNEY
> Yeah?

> LARSON
> I wouldn't normally do this, but I feel
> like this is kind of special.

> CAGNEY
> Agreed.

> LARSON
> See, sooner or later, we'll be at a
> restaurant and I won't be able to make
> out the menu or we'll look at a store
> sign and I won't know what it says.

> CAGNEY
> You're... dyslexic?

> LARSON
> Maybe. I don't know. I can't read.

> CAGNEY
> Get out of here.

> LARSON
> I'm serious.

> CAGNEY
> Everybody can read.

> LARSON
> No. Not everybody.

> CAGNEY
> I *mean*... How could you get through
> school?

> LARSON
> I got pushed along for a while, but
> eventually I just dropped out.

> CAGNEY
> That's *crazy!* I'm not sure I've ever—

> LARSON
> I know it's *weird*. That's why I wanted
> to tell you, so you didn't think I was...
> hiding it from you.

> CAGNEY
> I won't *lie*. I'm kind of not sure how to
> process it. Are you... still trying to
> learn?

> LARSON
> I want to, but the older I get, the
> harder it *gets*. Look, if it's too weird
> for you, I'll *understand*. There's a
> reason I don't usually tell people.

> CAGNEY
> I hope this is a compliment, but you
> seem too smart for this.

> LARSON
> Thanks, I guess. I don't know, though.

> CAGNEY
> You *are*. I'd like to try to help you
> with this.

Cagney can't help but smile.

> LARSON
> That sounds great, but let's try going
> out a second time first.

> CAGNEY
> When!

They laugh and Larson takes Cagney's hand.

Rosario enters.

> ROSARIO
> I give up.

J.P. looks up, confused.

> ROSARIO
> I surrender, throw in the towel, wave
> the white flag... whatever.

> J.P.
> Okay, so what's this all about?

> ROSARIO
> I'm just saying, I can't win with you,
> I see that now, so I'm not even gonna
> try.

> J.P.
> You serious?

> ROSARIO
> *Absolutely*. This is how it's gonna be
> now: I just want you to tell me what to
> *do*. You're in charge.

> J.P.
> Oh, I *can* do *this*. First order of
> business, let's correct the way you are
> saying this. It's not, "I can't win
> with you," it's, "I trust you to make
> good decisions for both of us."

> ROSARIO
> Uhhh... okay.

> J.P.
> Say it.

> ROSARIO
> *Really?* Okay. I trust you to make good
> decisions.

> J.P.
> Great *start*. Now how about, "I'm sorry
> for always being so controlling and not
> giving you enough credit."

> ROSARIO
> This is not what I had in mind.

> J.P.
> Surrender, remember? It was your idea.

> ROSARIO
> *I...* I'm sorry for being so controlling.

J.P. smiles wide.

> J.P.
> I think this could work out *well*. Next,
> "I promise to be a better partner and
> always include you in decisions."

> ROSARIO
> *C'mon...* Enough.

> J.P.
> You can't do it?

> ROSARIO
> Whatever, you're just messing with me.

> J.P.
> Oh, so even when we're just having fun,
> you can't let me be in charge for a
> minute.

> ROSARIO
> That was at least a minute.

> J.P.
> Not funny... at all.

> ROSARIO
> You're not actually mad?

> J.P.
> You think you're playing, but you're
> messing around some sore spots here. You
> should know better.

> ROSARIO
> Like I said, I can't win.

J.P. looks daggers at Rosario for a moment and stalks out.

> J.P.
> Surrender to this.

> ROSARIO
> Seriously, can't you see how I can't win
> with you?

Cairo enters and finds Harris slumped in a chair.

> CAIRO
> Hey, I'm here! You ready to go?

> HARRIS
> I don't know.

> CAIRO
> What do you mean?

> HARRIS
> I feel terrible. Like I've been beaten,
> gotta be the flu.

> CAIRO
> Oh no! I'm sorry.

> HARRIS
> Yeah, I don't mean to bail on you. Will
> you be okay without me?

> CAIRO
> Sure, but do you need me to get you
> anything? I'll stay if you want.

> HARRIS
> No, you should still go. I'll be fine.

> CAIRO
> Actually, you do *look* fine.

Cairo checks Harris's forehead for a fever.

> CAIRO
> This isn't because my parents are going
> to be there, is it?

Harris pulls away from Cairo's hand.

> HARRIS
> Don't be stupid. I'm sick.

> CAIRO
> This isn't going to be *meeting my
> parents*. They just happen to be there.

> HARRIS
> Meeting your parents is *meeting your
> parents*.

 CAIRO
Okay, but they're not all that terrifying.

 HARRIS
I'm sure they're very nice. Leave me
here, though, okay?

 CAIRO
You know what I mean, though, this
wouldn't be like presenting you to *them*.
This wouldn't be taking *that* step, if
that's what you're worried about.

 HARRIS
I'm just not up to it today, okay?

 CAIRO
Hmmm... Tell me what's *really* going on
here and I promise I'll leave you be.

 HARRIS
Okay. I just... don't want to be judged.

 CAIRO
What? You're amazing and smart and funny
and great looking. How could they judge
you as anything but spectacular?

 HARRIS
That's very sweet. You're making me feel
terrible about this.

 CAIRO
You should feel terrible. Think of how
lonely I'll be without you.

 HARRIS
You positive they'll like me?

 CAIRO
How can they not?

 HARRIS
Alright. I'll go get ready.

 CAIRO
You're awesome.

 HARRIS
Let's hope your parents think so.

Jameson sits across from Harley. Harley smiles. Jameson
stares suspiciously.

> HARLEY
> I'd like a raise.

> JAMESON
> You think you've got me over a barrel.

> HARLEY
> I don't know what you mean—in fact, I
> don't really understand that expression.

> JAMESON
> You think you saw something or think you
> know something and think you can use it
> against me.

> HARLEY
> I don't know what you're talking about.

> JAMESON
> So what will happen if I don't give you
> a raise?

> HARLEY
> I don't know, but I'm hoping you do.

> JAMESON
> So you're not threatening me? This isn't
> blackmail? I shouldn't worry if I don't
> give you the raise?

> HARLEY
> I don't know about *any* of that. I just
> want a raise.

> JAMESON
> Okay, but you'll have to admit what's
> actually going on here.

> HARLEY
> *Uh*... I'm asking you for a raise...

> JAMESON
> You know what I mean. Stop trying to be
> cute about this.

> HARLEY
> I don't know what you mean. Why don't
> you tell me what you think is going on?

> JAMESON
> And confess?

> HARLEY
> To what?

> JAMESON
> Nothing. Never mind. Forget this whole
> damn thing.

> HARLEY
> Oh, sorry to hear that.

Harley gets up to go.

> JAMESON
> Wait. How much?

> HARLEY
> How much of a raise? What do you think?
> Aren't you in charge?

> JAMESON
> How much will it take to make you...
> happy... with the way things are... now.

> HARLEY
> I'm not happy with the way things are
> now. That's why I'm asking for a raise.
> Am I not being clear?

> JAMESON
> Clear? I have no idea what we're
> actually talking about.

> HARLEY
> I just want a raise.

> JAMESON
> No, damn you! I say no! If you won't
> play it straight with me, forget it.

Harley starts to walk out.

> JAMESON
> I'll double your pay!

> HARLEY
> Double it? Really? Thank you. I'll try
> to make sure you don't regret it.

Harley leaves smiling. Jameson is confused and miserable.

Rafi walks in excited and Sorrel looks up.

> RAFI
>
> I had a real moment, like one of those
> moments of clarity, and I made a big
> decision.

> SORREL
>
> Oh yeah? What's that?

> RAFI
>
> I've decided I want to help people.

> SORREL
>
> That sounds nice, help people how?

> RAFI
>
> I have to figure that out still.

> SORREL
>
> Oh. Well, congratulations, I guess.

> RAFI
>
> Do you think I'm lying or something?

> SORREL
>
> Definitely not. I'm sure you're sincere.

> RAFI
>
> You sound all sarcastic and
> condescending. What are you getting at?

> SORREL
>
> Nothing. I'm glad you found some clarity
> or whatever.

> RAFI
>
> My God, you're the biggest cynic. Do you
> not think it's possible that someone can
> want to do something good?

> SORREL
>
> I'm sure you want to do something good.
> I'm just thinking maybe you want to
> figure out what that is before you make
> too much of a thing out of it.

> RAFI
>
> That's not the point.

 SORREL
Oh, what's the point then?

 RAFI
It's a direction, a commitment.

 SORREL
Right, but a commitment to what exactly?

 RAFI
Helping people! Why are you so hostile
to this?

 SORREL
I'm not hostile. I just don't think
you've made any sort of commitment until
you actually know what you're going to
do.

 RAFI
I could do anything.

 SORREL
Are you going to go help lepers in India
like Mother Teresa?

 RAFI
There's a lot of different ways to help
people.

 SORREL
No doubt. I suppose you're helping
people if you're getting them their Big
Macs or their Whoppers.

 RAFI
That's not what I have in mind.

 SORREL
Right. So what exactly do you have in
mind?

Rafi hesitates then starts to leave.

 RAFI
I don't know why you're trying to make
me feel bad about this.

 SORREL
I'm just trying to give you some
clarity. I want to help people too.

Kilo is scrutinizing Ash, who notices and turns away. After a
moment, Kilo approaches Ash.

 KILO
 Ash?

 ASH
 Sorry, what? I think you have me mixed
 up with someone.

 KILO
 It's Kilo, from grade school.

Ash shrugs.

 KILO
 C'mon, Mr. Osawa's class...

 ASH
 Sorry.

 KILO
 Where did you go to grade school then?
 What's your name?

Ash hesitates just enough.

 KILO
 That's what I thought. Look, I don't
 blame you for not wanting to deal with
 me. I was a bully.

 ASH
 Yah think?

 KILO
 I was terrible, I said terrible things,
 but I was a kid.

Ash just scowls.

 KILO
 I'm not saying that makes it okay. I'm
 just saying I grew up and I realize now
 how wrong I was.

 ASH
 Good for you.

 KILO
 I'm not trying to bother you, I just
 want to apologize.

 ASH
Done. Check it off your list.

Ash tries to leave.

 KILO
Please, give me a chance. If I could go
back, I would change the way I was, but
now, all I can do is say how wrong I was
and how sorry I am. I know we were
young, but I know I hurt you. Can you
forgive me?

 ASH
No.

 KILO
No?

 ASH
You don't get to try to change this now.
You are who you are to me. Because I ran
into you for five minutes, doesn't
change that.

 KILO
What am I supposed to do?

 ASH
How is that my problem?

 KILO
I... I don't know.

 ASH
So?

 KILO
I'm sorry to take your time. I'm sorry
for everything.

Kilo walks away sadly. Ash feels a little bad.

 ASH
Just do something good, okay. Do the
right thing for someone *else*. You can't
change the past, but you can change the
future. Right?

 KILO
Yeah. I will. Thanks.

Jonesie enters. Blye bristles.

 BLYE
 What do you want?

 JONESIE
 I'm trying to apologize here. Will you
 give me a chance?

 BLYE
 I'd rather you just left me alone.

 JONESIE
 I see why you would feel that way and
 that's why I'm here.

Blye tries to ignore Jonesie.

 JONESIE
 I deserve this. I know I screwed up. I
 know I hurt you, that's why I'm
 apologizing. I was wrong. I was stupid.
 I was hurtful.

Blye continues to ignore Jonesie.

 JONESIE
 I'm telling you I blew it. It's all on
 me. Can't you forgive me?

Blye tries to ignore Jonesie.

 BLYE
 I've been down this road too many times.

 JONESIE
 I know I've screwed up before. That
 doesn't mean I don't want to make it
 right this time.

 BLYE
 Do you think saying that you're sorry
 makes things right? Apologies don't
 change anything. If I say everything's
 okay, how long till we're right back
 here again?

 JONESIE
 You're right. You're right. I don't
 deserve your forgiveness. I don't
 deserve anything.

BLYE
Now you're making sense.

JONESIE
I'm trying to apologize, trying hard.

BLYE
I'm not doubting that, but I don't want
your apologies anymore. Don't you get
it? You can't just keep doing this and
thinking it's okay because you
apologize.

JONESIE
I... *Uh*... What should I do?

BLYE
I don't know? Why are you asking me?!

JONESIE
I need help. I don't know what to do.

Jonesie slumps. Blye considers.

BLYE
I don't think I can help you.

JONESIE
Really? You wouldn't help me?

BLYE
I didn't say that. I said I don't think
I can. I don't know who can. You want
help, but I think it's all on you.

JONESIE
Do you hate me?

BLYE
You hurt me, but I sincerely want you to
work it out, just not around me.

JONESIE
I should leave?

BLYE
You should leave.

Jonesie and Blye share a weak smile and Jonesie leaves. Once
alone, Blye is overwhelmed by sadness.

C.J. and Jordan are at the back of an acting class during warm-ups. They whisper to each other.

> C.J.
> This is not what I thought this was
> going to be. I wanted to be in a
> scene... deliver lines... emote.

> JORDAN
> I'm sure that'll come.

> C.J.
> But how much more "saluting the sun" and
> "lion mouth" am I going to have to do?

> JORDAN
> It's all part of the process. Be open to
> it.

They stretch along with whoever is leading the class and continue to whisper.

> C.J.
> I'm tired of "sending my energy." I'd
> like to keep a little.

> JORDAN
> Just pay attention.

> C.J.
> I wanted to be in a scene where we could
> argue or fight or something.

> JORDAN
> If we do scenes, we may not even be
> partners.

> C.J.
> What? I didn't know that...

C.J. looks around the class.

> C.J.
> I wanna be in a scene with the blonde
> then.

> JORDAN
> Don't be gross.

> C.J.
> Only if I can't be in a scene with you,
> of course.

 JORDAN
Yeah, right.

 C.J.
Seriously, why don't we cut out?

 JORDAN
What? You said you'd do this with me.

 C.J.
That's when I thought this would be
actual acting.

 JORDAN
What does that matter? The point is that
you're with me.

 C.J.
Yeah, but think of all the other places
I could be with you.

 JORDAN
You said you would try new things.

 C.J.
I tried. Didn't I try?

 JORDAN
Trying would be finishing the class, not
to mention paying attention.

 C.J.
So many conditions.

 JORDAN
You are not making this fun.

 C.J.
Oh... this is fun.

 JORDAN
Stop it. You're making me mad.

 C.J.
Wow, too bad we can't channel that into
a scene.

 JORDAN
You got your wish, because you have
turned *this* into a scene!

C.J. backs off, having pushed Jordan too far.

Berkeley walks by and Izaz jumps up.

 IZAZ
Oh, hey Berk, I'm glad to run into you.

 BERKELEY
Hey, what are you doing here?

 IZAZ
Just running errands, but it's great to
see you. I've been wanting to chat.

 BERKELEY
Oh?

 IZAZ
Yeah, you know Jaden Kelsey, right?

 BERKELEY
Yeah...

 IZAZ
Think you could introduce me?

 BERKELEY
Is that what this *is*?! You show up here
and just happen to run into me?!

 IZAZ
Hey, why so angry? It's just a favor.
Don't do it if you don't want to.

 BERKELEY
I'll pass then.

 IZAZ
Fine, but you hooked Kerrigan up, didn't
you? Am I different somehow?

 BERKELEY
You talked to Kerrigan?

 IZAZ
The only reason I came here is because
she kind of pushed me into it.

 BERKELEY
I did help her...

 IZAZ
Then why not me?

> BERKELEY
> It's just... I've still got some hard
> feelings.

> IZAZ
> You do? I had no idea. Maybe we should
> clear the air.

> BERKELEY
> Is that what you want or do you want the
> intro?

> IZAZ
> I want things to be good between us.

Berkeley sighs.

> BERKELEY
> Look I overreacted. You never really did
> anything. It's just... I... used to have
> a thing for you is all.

> IZAZ
> Are you kidding? You never said anything.

> BERKELEY
> I had no right to be angry about it.
> I never said anything because... I just...
> imagined you weren't interested.

> IZAZ
> But... I think I would have been. I
> mean... then.

> BERKELEY
> Look, I'll make the intro either way,
> but only if you can be honest here.

> IZAZ
> *Okay*... Maybe I wasn't interested then. I
> mean it's nothing against you.

> BERKELEY
> Right, of course.

Berkeley turns and walks away quickly.

> IZAZ
> Wait! The intro... You said you wanted me
> to be *honest*. *Damn*. I told Kerrigan this
> was a bad idea.

Campbell is talking on the phone. Shaw approaches.

 CAMPBELL
 ...I seriously don't know... Right?

 SHAW
 Excuse me.

 CAMPBELL
 Can't you see I'm on the phone?

 SHAW
 Sorry to interrupt, but is that Ashley?

Campbell is thrown by this, and creeped out in general.

 SHAW
 On the phone... Ashley... Ashley Aron?

 CAMPBELL
 Sorry, do I know you?

 SHAW
 You're Campbell, right? Ashley's talked
 about you. I'm Shaw.

Shaw extends a hand to shake, but Campbell remembers the phone
and lifts it to speak instead.

 CAMPBELL
 Ashley, sorry about that, but I just ran
 in to your friend... Shaw. Yeah.

Campbell lowers the phone.

 CAMPBELL
 Ashley says, "Hello."

 SHAW
 Do you mind if I say hello?

Campbell reluctantly hands the phone to Shaw.

 SHAW
 Ashley? Yeah! Right? Campbell?

Shaw begins staring at Campbell. Who is unnerved.

 SHAW
 I see exactly what you were talking
 about. Right? Always great. You too.

Shaw hands the phone back.

> CAMPBELL
> Ashley... Ashley?

> SHAW
> Ashley had to go.

> CAMPBELL
> How did you know I was Campbell?

> SHAW
> Something Ashley said, I'm sure.

> CAMPBELL
> What?

Shaw shrugs.

> CAMPBELL
> You said, "I see *exactly* what you were
> talking about."

> SHAW
> I think I should go.

> CAMPBELL
> And what did I say that made you think I
> was talking to Ashley?

> SHAW
> I don't remember.

> CAMPBELL
> ...And why were you listening in on my
> conversation anyway? I'm calling 911.

Shaw backs away then turns and runs. Campbell's concern melts
away. Campbell chuckles, dialing the phone.

> CAMPBELL
> You might as well answer, Ashley, I know
> that was you trying to get me back for
> that April fools' scare I gave you.

Campbell hangs up and looks in the direction Shaw left.

> CAMPBELL
> ...I hope.

Perkins pushes past Juno to enter.

> JUNO
> Invite yourself in why don't you?

> PERKINS
> I just want to talk.

> JUNO
> You're talking. Can I stop you?

Perkins sits, looks expectantly at Juno.

> PERKINS
> Sit and talk with me a few minutes and
> then I'll go

Juno sighs and plops down.

> PERKINS
> You know I love you and care about you?

> JUNO
> What?

> PERKINS
> I'm worried about you. I think you're
> drinking because you're hurting and it's
> getting more and more self-destructive
> and I want to help you.

> JUNO
> You... should probably leave...

> PERKINS
> The most important thing is that you
> acknowledge there's an issue here.

> JUNO
> Wait, is this an intervention?

> PERKINS
> It's supposed to be. I saw one on TV.

> JUNO
> Well, you should have watched more
> closely because you're supposed to bring
> a group.

> PERKINS
> I tried. You've pissed off everyone
> else.

 JUNO
I need to work harder on *you* then.

 PERKINS
Why? Why are you pushing everyone away?

 JUNO
Isn't this supposed to be about my
drinking?

 PERKINS
Honestly, the drinking's not that big a
deal to *me*. I know some really fun
alcoholics.

 JUNO
Functional alcoholics?

 PERKINS
Those too.

Juno chuckles a little.

 JUNO
I'm not trying to hurt anyone, least of
all you.

 PERKINS
What's this all about then?

 JUNO
I'd rather be alone, okay? Because...
everyone else has got it together and *I
don't*. It's... embarrassing.

 PERKINS
You think we have it together? We don't,
I swear. I don't anyway. I totally
screwed up this intervention.

 JUNO
No. You did fine. Great actually.
Thanks.

Juno puts an arm over Perkins's shoulder.

 PERKINS
Cool. What do we do now?

 JUNO
I don't know. How 'bout a drink?

Astin walks in and notices Huan looking down.

 ASTIN
 You okay?

 HUAN
 Hmmm? Yeah.

 ASTIN
 You sure? You're giving off a vibe.

 HUAN
 I don't mean to. I'm okay.

 ASTIN
 Yeah, I don't think so.

 HUAN
 I've been better, but I'm okay.

 ASTIN
 Seriously, tell me what's going on. You
 know you can trust me don't you?

 HUAN
 Well... I was at a party last night...
 and I... had a blackout.

 ASTIN
 Wow. You mean, like drugged, maybe?
 What do you remember?

 HUAN
 I didn't even drink that much. I was
 dancing and then bam—nothing.

 ASTIN
 Sure sounds like drugs. What's the next
 thing you remember?

 HUAN
 I woke up upstairs in the house where
 the party was... in a bed.

 ASTIN
 Was there... I mean, were you... alone?

Huan nods "yes."

 ASTIN
 And do you think anything... happened?

Huan shrugs.

> ASTIN
> You have to kind of know, don't you?

> HUAN
> I... I'm... I think... something
> happened.

> ASTIN
> You have to tell somebody. You have to.
> This is a crime, right?

> HUAN
> I have no idea what happened. What could
> I say?

> ASTIN
> There were other people there. Somebody
> saw something. The police will talk to
> everyone and figure it all out. It's
> their job.

> HUAN
> I don't think I want them talking to
> everyone about me. I don't even really
> know what happened. It's my decision,
> right? It happened to me.

> ASTIN
> Yeah, of course... but I don't want you
> to end up regretting this.

> HUAN
> I'm already regretting this. I just
> don't want to make it worse.

They are both quiet a long moment.

> ASTIN
> I understand. I do. It's not easy.
> It... It happened to me once.

> HUAN
> Oh my God! You... I'm so sorry.
> What... What did you do?

> ASTIN
> I... never told anyone... till now.

Astin looks down in shame. Huan moves closer to Astin. After a
moment, Astin takes Huan's hand and they sit together quietly.

Edison and Jayden sit in the same area, but are not together.
They both are immersed in reading.

> EDISON
>
> Hmmm...

> JAYDEN
>
> What?

> EDISON
>
> What? Nothing... Sorry.

> JAYDEN
>
> Okay.

They both go shyly back to reading, though both have lost
their concentration.

> EDISON
>
> It's just when I read...

> JAYDEN
>
> What?

> EDISON
>
> I sometimes make noises when I read. I
> don't mean to. Sorry.

> JAYDEN
>
> No big deal.

They both go back to reading.

> EDISON
>
> Only when it's good, though.

> JAYDEN
>
> I'm glad—that you're reading something
> good.

> EDISON
>
> Right. Yeah.

They both go back to reading for a long moment.

> JAYDEN
>
> Ssssst.

> EDISON
>
> What?

 JAYDEN
 Huh?

 EDISON
 You said something?

 JAYDEN
 No.

 EDISON
 No, you did. You said, "Ssssst."

 JAYDEN
 Ssssst? Really?

 EDISON
 Must be good. What you're reading.

 JAYDEN
 You've read it?

 EDISON
 No... I meant... Because when I...
 Uh... Nevermind.

They both go back to reading.

 JAYDEN
 Phffft.

Edison looks up, considers saying something, but thinks better
of it.

 JAYDEN
 Pah.

Edison smiles, but pretends to continue reading.

 EDISON
 Hmmmph.

 JAYDEN
 Sheesh.

 EDISON
 Buh, buh, buh, buh!

 JAYDEN
 La, la, la, la!

They both start laughing and make full eye contact for the
first time.

Reagan and Jamie are sitting next to each other.

 REAGAN
 Whew, that movie sucked!

 JAMIE
 That seems kind of harsh.

 REAGAN
 You liked it?

 JAMIE
 It wasn't really my thing, but I don't
 think it *sucked*.

 REAGAN
 Take my word for it then, it sucked.

Jamie considers letting it go, but can't.

 JAMIE
 Just because you don't like something,
 doesn't mean it sucks.

 REAGAN
 What does it mean then?

 JAMIE
 It's just too strong a condemnation. It
 takes it out of the context of your
 opinion and turns it into some kind of
 universal proclamation.

 REAGAN
 What?

 JAMIE
 Did you ever consider all the hundreds—
 or thousands—or whatever people who work
 on a movie like this? Maybe there's a
 problem with this part of a movie or
 that part of a movie, but how can you
 just negate an entire movie and all the
 work that goes into it? How can you
 negate everyone who worked on the movie?
 Did the lighting really suck? Did the
 sound really suck? How do you know,
 maybe the catering was great!

 REAGAN
 What's with you?

JAMIE

Nothing's with me! I'm not the one who
said the movie sucked!

REAGAN

I didn't mean anything personal.

JAMIE

Didn't you? What did you mean then?
Weren't you trying to assert some kind
of superiority? Isn't that always why
everything sucks to you?

REAGAN

Uh... I'm allowed to have my own opinion.

JAMIE

Yes, *your* opinion: *I didn't care for it,
it wasn't for me*, not *it sucked*!

REAGAN

It's just an expression.

JAMIE

Is it an expression when you say Lee
sucks? Is it an expression when you say
Kelly is shallow or J.R. is fat? You're
just judgmental.

REAGAN

Is that what this is about? I never say
stuff like that about you, if that's
what you're worried about.

JAMIE

Do you think I'm that shallow? Why would
you think I'd be worried about that?

REAGAN

Why else would you care about all this?

Jamie's jaw drops.

JAMIE

Wow... You... You... suck.

Jamie storms off.

REAGAN

Maybe, but so did that movie.

Thyme pushes past Sloan to enter.

> SLOAN
> Can't you leave me alone?

> THYME
> I'm worried about you.

> SLOAN
> Just let me mourn.

> THYME
> Of course, you lost somebody, I know
> that, but you can't shut us all out.

> SLOAN
> Everybody grieves their own way.

> THYME
> I'm just worried—a lot of us are
> worried.

> SLOAN
> Look. It's grief. It's not a crisis.
> It's a process. I'll work through it.
> It just takes time.

> THYME
> How long?

> SLOAN
> I don't know... I might feel a little
> better tomorrow and a little better the
> day after that, but it's not like a cold
> you just get over one day.

> THYME
> Okay, but how long till... you'll go out
> for a drink... or a *coffee*? How long
> till you stop trying to get rid of me?

> SLOAN
> This is not about *you*.

> THYME
> But I miss Butler too, and it's worse
> cause it's kind of like I lost you both.

> SLOAN
> That's... nice. That's very nice. It's
> just...

 THYME
What?

 SLOAN
It... was *not* an accident.

 THYME
What? Of course it was.

 SLOAN
Butler drove off the road... on purpose.

 THYME
You can't know that. Butler was alone in
that car.

 SLOAN
There was... a note.

 THYME
No... there wasn't.

 SLOAN
I destroyed it. I didn't want people
remembering Butler like that.

 THYME
And you've been carrying that...?

Sloan shrugs. Thyme tries to hug Sloan, who resists.

 SLOAN
Will you let me work through this now?

 THYME
Not alone.

 SLOAN
Really?

 THYME
Really.

 SLOAN
Okay. I'll stop trying to get rid of you
if you stop grilling me, okay?

Thyme nods in agreement and Sloan turns away. Thyme puts a
hand on Sloan's shoulder. Sloan pretends not to like it, but
after a moment, Sloan smiles just a little.

Joss walks in, clearly in pain. Gale looks up.

 GALE
 You need to stop messing around and see
 a dentist, Joss.

 JOSS
 Dentists can all burn in hell.

 GALE
 Nobody *likes* the dentist, but people go
 when they're in pain. I'll call my
 dentist for you. She's good. You'll
 like her. I'll even take you.

Gale pulls out a phone.

 JOSS
 No. I'll do it. I'll go, just don't
 rush me.

 GALE
 Who's rushing you? It's been weeks and I
 think you're avoiding solid foods at
 this point. What's really going on here?

 JOSS
 I'm afraid, okay?

 GALE
 A lot of people are afraid of dentists.
 It's quite common, but c'mon, you need
 to go if you're in pain.

 JOSS
 I know it's not rational. I'm not saying
 it's rational. It's emotional and a
 little crazy. Don't you have any
 irrational fears?

 GALE
 Sure... yeah.

 JOSS
 What?

 GALE
 I... Well... I'm irrationally afraid of
 rejection.

 JOSS
You are? Like how?

 GALE
Well, if there's someone I like, I can't
express it. I'll hide it completely. I
know I'm afraid they might not feel the
same way, but it feels like more than
that.

 JOSS
I know, I know, it's not rational,
right?

 GALE
Yeah. It's like I'm paralyzed or
something.

 JOSS
Wow. It makes me feel better that you
shared that, but now I feel bad for you.
Is there someone you like *now*?

Gale can't meet Joss's eye.

 JOSS
Wait. Are you saying?

Joss processes the realization. Gale still can't look up, but
faintly nods "yes."

 JOSS
Oh my God, really?! How long? I never—

 GALE
I just faced my fear in a *big way*, will
you just shut up and go to the dentist
with me now?

 JOSS
Wait, this is kind of... Are you asking
me out?

 GALE
No. Don't even—

 JOSS
Yes! I want to go out with you... even
to the damn dentist.

Gale finally looks up and smiles. Joss tries to return the
smile, but winces in pain.

Zen is reading something as Terry paces around nervously.

> TERRY
> Try to ignore the punctuation. I'm not
> good at punctuation.

> ZEN
> Mmmm hmmm.

> TERRY
> I'm sure I didn't handle some of the
> quotation mark things right either.

> ZEN
> That's punctuation too.

> TERRY
> Oh. Right. Maybe you—

> ZEN
> Are you gonna let me read this?

> TERRY
> Sure, sorry.

Zen goes back to reading. Terry goes back to pacing.

> TERRY
> I'm not sure about the whole thing with
> the French guy. If that bothers you, try
> to ignore it.

> ZEN
> Are you *sure* you're ready for me to read
> this?

> TERRY
> Yeah... I thought I *was*... I'm just
> worried. It's not terrible, is it?

> ZEN
> I'm feeling a lot of pressure here to
> react positively. You want my honest
> opinion, don't you?

Terry hesitates.

> TERRY
> Yes. That's what I want. I'll shut up.

Zen goes back to reading. Terry watches.

 TERRY
What?

 ZEN
What?

 TERRY
That face.

 ZEN
What face?

 TERRY
Like you didn't like something.

 ZEN
How about if I take this home to read
and then come back.

 TERRY
No. I'll die while I'm waiting.

 ZEN
I think you're dying now. Look it's
clear to me that you can write, but that
doesn't mean you're cut out to be a
writer.

 TERRY
That's a terrible thing to say.

 ZEN
Look writers write in order to share
what they have to say with the world.
Are you sure you want that?

 TERRY
Of course I want that. I shared it with
you, didn't I?

 ZEN
Not exactly. Sharing it means being okay
with *all* your readers' reactions: good
and bad. Sorry.

Zen hands the story back to Terry.

 TERRY
God, it must be terrible.

Zen starts to respond, but just walks out instead.

Baylor and Donnel are getting ready to leave.

> BAYLOR
> You ready?

> DONNEL
> Yep.

> BAYLOR
> Let's go then. Wait! Do you have the keys?

> DONNEL
> Of course.

> BAYLOR
> Show me?

> DONNEL
> Really?

> BAYLOR
> Please.

Donnel pulls out keys and jingles them in Baylor's face.

> BAYLOR
> Maybe I should have the keys.

> DONNEL
> Why?

> BAYLOR
> You lose things.

> DONNEL
> What? What did I lose?

> BAYLOR
> You lost your wallet.

> DONNEL
> That was a year ago and I found it.

> BAYLOR
> Just gimme the keys.

Baylor gestures for the keys, but Donnel holds them tight.

> DONNEL
> Why are you doing this?

 BAYLOR
 I just want the keys, don't make a thing
 out of this.

 DONNEL
 Why don't you trust me?

 BAYLOR
 I trust you, okay. It's me. It's all me.
 I'll feel better if I have the keys.

 DONNEL
 So your admitting this is you being a
 total neurotic?

Donnel holds the keys out, but Baylor just stares angrily.

 BAYLOR
 Fine, you keep the damn keys.

 DONNEL
 Oh, go on, if you want the keys, you can
 have them.

Donnel extends the keys toward Baylor, who dodges.

 BAYLOR
 Get away from me with those keys.

 DONNEL
 You know you want them. Take them.

Donnel chases Baylor with the keys playfully.

 BAYLOR
 I'm going to stick those damn keys you
 know where.

They both laugh, sort of chasing, sort of dancing till Donnel
stumbles a little and has to take a knee.

 BAYLOR
 Are you okay?

Donnel nods "yes" and they both laugh again. Baylor helps
Donnel up, and they laugh themselves out.

 BAYLOR
 Seriously though, gimme the keys.

Benson walks in cautiously on Ronny.

 BENSON
 Everything okay?

 RONNY
 Fine.

 BENSON
 Cool. You know... everyone's kind of
 waiting on you out there.

 RONNY
 Okay. Just let me...

 BENSON
 ...What?

Benson waits for a response from Ronny, but none comes.

 BENSON
 You've been in here for like twenty
 minutes... which is like losing twenty
 hours on our schedule.

 RONNY
 I... I... can't go back out there.

 BENSON
 Of course you can. We need you.

 RONNY
 No. They saw me... I cried. How can
 they take me seriously now?

 BENSON
 Is that all you're worried about? I'm
 sure hardly anybody saw that.

 RONNY
 Did you see it?

 BENSON
 Okay, people saw it, but it wasn't that
 bad.

 RONNY
 How could it not be bad?

 BENSON
 Because *everybody* cries.

 RONNY

Not leaders, *leaders* don't cry.

 BENSON

Says who?

 RONNY

That's the way everyone thinks. I showed
I was weak. No one wants to follow a
weak leader.

 BENSON

Maybe some people still think that way,
but c'mon, don't we know now that
strength and sensitivity are not
mutually exclusive?

 RONNY

Seriously?

 BENSON

I guarantee if you go out there and tell
us what to do, we'll do it.

Ronny stands, but still looks uncertain.

 RONNY

Why'd you come in here?

 BENSON

We need to get going or we'll all end up
looking bad.

 RONNY

But why *you*?

 BENSON

Oh. Well... I don't know... It just
had to be done.

 RONNY

You. You're a *leader*.

 BENSON

Yeah? Well, I cry all the time, alright?
So let's go.

Benson heads out confidently. After a moment of hesitation,
Ronny snorts, shrugs and heads out too.

Kai enters. Sam looks up and sighs.

> KAI
> I'm sorry about this.

> SAM
> I've been clear, I just want to be left
> alone.

> KAI
> I know.

> SAM
> Then what are you doing here?

> KAI
> I needed to see you.

> SAM
> Why does what you want matter? Are you
> the sick one?

> KAI
> I can see you're hurting. This whole
> thing sucks in an unbelievable way. It
> gives you some... license, I do get that.

> SAM
> Do you?

> KAI
> I do. I just don't think it gives you
> the right to box everyone out.

> SAM
> It's my life, what's left of it.

> KAI
> What about Carsey's life? What about Jo?
> What about me?

> SAM
> How is this about *you*?

> KAI
> Are you kidding? I'm losing you. We're
> losing you. How are we supposed to deal
> with that?

> SAM
> Not my problem.

 KAI
 Right. Exactly. You'll be gone and we'll
 still be here dealing with it, all the
 worse because of the way you treated us
 at the end.

Sam is shaken.

 SAM
 Don't do this to me.

 KAI
 I'm not trying to hurt you. We're all
 hurting from this.

 SAM
 I'm allowed to die in my own way.

 KAI
 You are. Of course, you are, but maybe we
 can help. Maybe we can all help each other.

 SAM
 I'm a private person.

 KAI
 I know. We know. We'll give you space, a
 lot of space, just let us in.

 SAM
 Okay.

 KAI
 Okay?

 SAM
 Come by tomorrow.

 KAI
 Seriously? That's great—amazing!

 SAM
 Don't make a big thing out of it or I
 might change my mind. Leave me for now
 and you can bring whoever tomorrow.

 KAI
 Great! We'll be over around lunch.

Kai smiles and runs out excited.

 SAM
 Just don't expect me to be here.

August rushes in holding a phone. Iritza looks up.

> AUGUST
> Were you looking at my phone?

> IRITZA
> What? No. Why?

> AUGUST
> It wasn't where I remember leaving it.

> IRITZA
> Well, I didn't touch it.

> AUGUST
> Okay, good.

August starts to walk out. Iritza considers.

> IRITZA
> Am I not allowed to touch it? Why is
> this such a thing?

> AUGUST
> I basically thought you were checking up
> on me or something and I didn't like it.

> IRITZA
> Why? Is there something you don't want
> me to see on your phone?

> AUGUST
> No. It's just a privacy thing, you know?
> You trust me, don't you?

> IRITZA
> Well, I did trust you, but now I kind of
> don't because you're acting really
> suspicious.

> AUGUST
> Seriously, you know you can trust me. I
> don't hide things from you.

> IRITZA
> Let me see your phone then.

> AUGUST
> What?

 IRITZA
 Let me take a look at it and then I'll know
 I can trust you.

Iritza extends a hand, but AUGUST holds onto the phone.

 IRITZA
 Do you have something to hide or not?

August slowly hands the phone over and Iritza looks at it.

 IRITZA
 It's locked. You're going to need to
 unlock it.

Iritza hands it back. August takes it and walks away typing
away on the phone furiously.

 IRITZA
 Just unlock it.

 AUGUST
 Right. I'm just...

 IRITZA
 Just what? Are you deleting stuff?

 AUGUST
 No.

 IRITZA
 What are you doing then?

 AUGUST
 There was just a thing... nothing...
 really.

August finishes typing furiously and finally holds the phone
out to Iritza.

 AUGUST
 Here.

Iritza just stares at August in disbelief.

 IRITZA
 I don't need to see it now. You have
 proven without a doubt that I cannot
 trust you. In fact, I don't even want to
 see *you* right now.

Iritza leaves angry. August watches sadly a long minute, then
turns to the phone and begins typing away again.

Jet and Kason are heading in opposite directions when they see each other.

 JET
 Hey, K. what's up?

 KASON
 Long time no see.

 JET
 Yeah, been a minute. Let's get a pic.

 KASON
 A picture?

 JET
 Yeah, capture the moment.

Jet pulls out a phone and starts to line up a selfie with Kason, but Kason pulls away.

 KASON
 What moment? The moment when we passed
 each other and said hello?

 JET
 Yeah, I guess...

 KASON
 Why in the world would you need to
 capture *this* moment?

 JET
 Yo, you don't like pictures or
 something, I'm cool with that.

 KASON
 I like pictures! I love pictures.
 Pictures are great when they're of
 something.

 JET
 You and me, that's something, especially
 when I ain't seen you in a minute.

 KASON
 Are you sure this isn't some dumb knee
 jerk you've developed to post pictures
 of everything and try to make it seem
 like you're living a great life?

 JET
 I don't need pics to prove anything. I
 do live large and pics are just a part
 of how I choose to do it.

Kason considers a long moment.

 KASON
 Have I overreacted?

 JET
 A bit.

 KASON
 I'm sorry. I've had a tough day.

 JET
 Ha, ha, you had a tough day? My favorite
 auntie died.

 KASON
 Wait, your aunt just died and you're
 worried about getting a picture with me?

 JET
 Gotta stay positive.

Kason stares in disbelief.

 KASON
 I am not going to get into this again.
 To each their own, right? I'm sorry for
 your loss... sincerely.

 JET
 Thanks, she was special.

 KASON
 Yeah, condolences, and it was great to
 see you... and sorry about everything.

Kason starts to leave.

 JET
 Let's get that picture, though.

Kason stops, shocked again, but Jet goes ahead and lines up
the picture. Kason tries to go with it and leans into Jet's
picture, smiling awkwardly. Jet looks at the picture
approvingly and walks away staring at the phone and smiling.
Kason remains dumbfounded.

Z and Hanson look around.

 Z
 Looks like that's pretty much
 everything. I don't need that couch,
 you can have it.

 HANSON
 I don't want that couch.

 Z
 You sure? It's much nicer than any of
 your crappy stuff.

 HANSON
 Really?!

 Z
 Do you know what that couch cost?

 HANSON
 I don't care what you paid for it, it's
 ugly.

 Z
 Wow, is that what you always thought?
 You never said anything.

 HANSON
 You liked it. It didn't matter that much
 to me.

 Z
 Wow. What else have you been keeping to
 yourself?

 HANSON
 Let's not get into that now, let's just
 say goodbye.

 Z
 "Get into that"? Sounds ominous. Do
 you have some secret issue with me or
 something? C'mon, we're not roommates
 anymore, let's hear it.

 HANSON
 You sure?

 Z
 Bring it.

 HANSON
Okay. You're arrogant, selfish, and
self-obsessed.

Z is taken aback, but laughs after a moment.

 Z
Awesome! That was great! Quiet, polite
Hanson finally vents a little. Too bad
it's so late.

 HANSON
Too bad? I kept things peaceful around
here.

 Z
Made things boring. Do you think anybody
likes prissy phonies?

 HANSON
You're just trying to get back at me
because of what I said.

 Z
Calling me arrogant? Why would I even
care? I've got plenty to be arrogant
about. More than *some* people.

 HANSON
Wow. So looks like you've been holding
in your true opinion too.

 Z
I didn't want to hurt the "precious
snowflake."

 HANSON
The "precious snowflake" thinks you're an
insufferable ass.

Z laughs again, infuriating Hanson.

 Z
Well at least you're finally out of your
shell. Maybe there's hope for you yet.

Z extends a hand. Hanson look at it uncertainly.

 HANSON
Let's just say we said goodbye.

Hanson walks out without shaking Z's hand.

Lee enters, sees Chris, and stops short.

> LEE
> What are you doing here?

> CHRIS
> *What?!* Oh, sorry I didn't know you were
> going to be here.

> LEE
> Doesn't explain what you're doing here.

> CHRIS
> I'm sorry. I know, I'm not supposed to
> be here. I just came for a couple things
> and then...

> LEE
> Actually, I'm sorry I asked. I don't
> really want to know why you're here. I
> just want you to leave.

> CHRIS
> Calm down, please.

> LEE
> Why should I be calm? I should call the
> police.

> CHRIS
> Would you? You wouldn't? You think
> this isn't embarrassing enough? This is
> humiliating. I'm not disconnected from
> reality.

> LEE
> That's reassuring. I mean that you're
> not disconnected from reality, not that
> you're humiliated.

> CHRIS
> I never went through anything like this.
> I know I'm not handling it well.

> LEE
> It's a lot to deal with. I realize that,
> but... you just can't be here.

> CHRIS
> I'll go. Sorry... for everything.

Chris sighs deeply, starts to leave.

 LEE
 I'll need the key this time.

 CHRIS
 Oh.

 LEE
 Yeah.

Chris hesitates.

 CHRIS
 Are you sure?

 LEE
 After this?

 CHRIS
 Right...

Lee extends a hand. Chris pulls out the key, but freezes.

 LEE
 Nothing's changing. You're not going to
 need it. You can't be coming in here
 like this.

 CHRIS
 I know. It's just hard for me.

 LEE
 What is so hard? Just give me the key!

 CHRIS
 Please don't get angry again.

 LEE
 Right. Sorry. I am sorry, about...
 everything. I know this isn't all on
 you, but it is over. You need to move
 on. We need to move on.

 CHRIS
 You're right. You were usually right.
 You were right more often than I—

 LEE
 Move. On.

Chris smiles weakly, after a long moment hands the key to Lee,
and finally leaves.

Jude walks in and sees Ahsan. Both are startled.

> JUDE
> What the hell are you doing here?

> AHSAN
> I don't know what you're talking about, but you need to get out of here!

> JUDE
> You need to relax. You're the one in my place.

> AHSAN
> Relax? You broke into my apartment!

> JUDE
> I didn't break in. I have a key. See?

Jude holds up a key.

> AHSAN
> What does that prove?

> JUDE
> Well, I also have a lease... which I'm pretty sure you don't.

> AHSAN
> I rented this place. I paid and have all the paperwork.

> JUDE
> I'm thinking you've been scammed. I've heard about something like this where somebody pretends to be a broker. They can be pretty convincing apparently.

> AHSAN
> No... this place was empty.

> JUDE
> I've been travelling and don't have much stuff, but that's my bed, my fridge, my dresser. One question: you pay cash?

Ahsan nods "yes."

> JUDE
> To a "broker"?

Ahsan nods "yes."

 JUDE
Where'd you find this broker?

 AHSAN
I met her... at a bar.

 JUDE
Yeah, you've been scammed. Sorry.

 AHSAN
I should have known it was too good to
be true. A place I could afford... such
an easy move in. Dammit!

 JUDE
I wonder what happened to my stuff?

 AHSAN
The closet is full of boxes. The broker
said—Gah! I feel so stupid! What am I
supposed to do? I gave her almost all my
money. I won't get paid again for
another week and a half.

 JUDE
Are you looking at me?

 AHSAN
C'mon, we're both kind of victims here,
just till I get paid, please?

 JUDE
Where? I don't have a couch.

 AHSAN
I do. It should get delivered any
minute. I spent some money on
furniture... so... I didn't give it *all*
to the "broker."

They share a small laugh.

 AHSAN
Please? You can keep the sofa. I don't
have a place for it anyway.

Jude considers a long moment, sighing.

 JUDE
How about helping me get my stuff out of
those boxes and we'll go from there?

Jude extends a hand. Ahsan smiles and shakes it.

Brazil walks in on Loxie.

> BRAZIL
>
> I don't think you should take J.J. with
> you to New York.

> LOXIE
>
> Okay... Why not?

> BRAZIL
>
> I think it's a mistake.

> LOXIE
>
> Okay, but why?

> BRAZIL
>
> I don't think J.J. really cares about
> you.

> LOXIE
>
> What makes you think that? Did you hear
> something about J.J.?

> BRAZIL
>
> No...

> LOXIE
>
> Then what's this about?

> BRAZIL
>
> Well... I'm not sure you're going with
> the right person, is all.

> LOXIE
>
> Who's the right person then?

They share a look and Loxie realizes.

> LOXIE
>
> *You*?

> BRAZIL
>
> Of course. I should be going with you.

> LOXIE
>
> What in the heck would you do in New
> York?

> BRAZIL
>
> Be with you.

 LOXIE
Oh...

 BRAZIL
J.J.'s only going for selfish reasons—
using your move—taking advantage of you.

 LOXIE
So you don't just want to go with me,
you want to go *with me*?

 BRAZIL
I know it's sudden, but I've actually
felt this way a long time.

 LOXIE
Really? How long?

 BRAZIL
I don't know, a year... or two.

 LOXIE
And you never said anything until now?

 BRAZIL
I've been too scared. I see that now,
but I'm ready to stop being afraid.

 LOXIE
That's great, but it just doesn't work
now.

 BRAZIL
It doesn't have to work now. It only has
to work in New York.

 LOXIE
But we needed to date, to get to know
each other better. I mean, we've never
even...

 BRAZIL
It's not too late for that.

 LOXIE
Are you saying you would... with me...
now?

 BRAZIL
In a New York minute.

Brazil smiles and after a moment of shock, Loxie smiles back.

Kim and Rohan wake up in bed next to each other, a little
bleary.

 KIM
 Oh.

 ROHAN
 Hey.

 KIM
 Wow, right?

 ROHAN
 Right... wow.

 KIM
 You seem... like, surprised.

 ROHAN
 Sort of, I just... don't remember
 everything from last night.

 KIM
 We drank like... a lot, yeah, but you
 aren't disappointed, are you? I mean
 this isn't totally unexpected.

 ROHAN
 No, it's just... a lot.

 KIM
 Right, but I mean... I won't lie, when
 you woke up and saw me... you seemed a
 little disappointed.

 ROHAN
 I'm sorry, I didn't mean—I mean, you
 misread—I mean... I don't regret this.

 KIM
 Good.

Kim smiles and Rohan smiles back, but is still troubled.

 KIM
 What?

 ROHAN
 Nothing.

 KIM
 That look, what is it?

ROHAN
I'm just trying to remember.

KIM
I mean you don't think... I took advantage
of you or something?

ROHAN
God no! I definitely *wanted this*.

KIM
What's going on then?

ROHAN
I just didn't... want it *like this*...

KIM
How did you want it then?

ROHAN
I don't know, more special, more...
romantic.

KIM
That's how you feel about me?

ROHAN
Yeah... sorry—I know we just—you know—and
I'm not trying to force you into
something more already.

KIM
No, no, I don't have any regrets either—I
mean, except that this wasn't
the way you wanted it.

ROHAN
I shouldn't complain.

KIM
No. We should do this right. How about
a do over? We'll forget this ever
happened, and tomorrow, we'll go out on
a date—like on a *first* date.

ROHAN
A nice romantic evening?

KIM
...And easy on the drinking.

Lupe approaches Emery.

> LUPE
> Crazy last night, huh?

> EMERY
> Yeah, I don't know nothing about that.

> LUPE
> So you weren't here? It was pretty late,
> where were you?

> EMERY
> I was here, I just must have slept
> through everything.

> LUPE
> It happened right outside your place.
> You slept through *gunshots*?

> EMERY
> Hard sleeper.

> LUPE
> You heard *about* it, though, didn't you?

> EMERY
> Don't interest me much.

> LUPE
> A shooting right here doesn't interest
> you?

> EMERY
> None of my business.

> SAM
> Is this like a see no evil, speak no
> evil thing?

> EMERY
> I got nothing to say to nobody.

> LUPE
> You're a pretty bad liar. You know that?

> EMERY
> I think we about done here.

Lupe tries to leave.

> LUPE
> I feel you. I'd be afraid too.

 EMERY
 I never said I was afraid.

 LUPE
 You're a bad liar, remember?

 EMERY
 Doin' the sensible thing don't mean
 you're afraid.

 LUPE
 These bangers win when they scare all
 the good people into playing *their* game.

 EMERY
 I ain't playin' no game.

 LUPE
 Sure you are, it's called *chicken*.

 EMERY
 Real cute. What am I supposed to do?

 LUPE
 The *right* thing.

 EMERY
 Easy for you to tell me what to do.

 LUPE
 Yeah? You think it was easy for me to
 talk to those cops after everything that
 happened last year with Angel. But when
 a kid gets shot, that needs to be
 everybody's business.

Emery softens.

 EMERY
 I feel for you on that. I do. But I
 gotta take care of my own, end of story.

 LUPE
 End of nothing, really, because there's
 gonna be more shootings till we all
 stand up against it.

Lupe stares Emery down a long moment and then walks off. Emery
is clearly troubled.

Glenn storms in.

> GLENN
> Are you sleeping with Chris?

> PEREZ
> Sorry, what?

> GLENN
> You heard me.

> PEREZ
> That's none of your business.

> GLENN
> None of my business? You know I've been
> with Chris, don't you?

> PEREZ
> How does that make it your business?

> GLENN
> Just yes or no.

> PEREZ
> Just... none of your business.

> GLENN
> Okay. You should probably know: Chris
> and I are actually still together.

This is clearly news to Perez.

> GLENN
> Does that make it my business?

> PEREZ
> That makes it that you have a hell of a
> nerve even coming in here.

> GLENN
> Ha! Then you are sleeping with Chris.

> PEREZ
> None. Of. Your. Business.

> GLENN
> Okay. Then it probably won't interest
> you that Chris tested positive.

> PEREZ
> For what?

> GLENN
> Why should you care?

> PEREZ
> C'mon why wouldn't I care? We all know
> Chris.

> GLENN
> Just how well, though? You wanna know
> what's up with Chris, you're going to
> have to come clean.

> PEREZ
> I could just call Chris.

They stare at each other a long moment till Glenn shrugs and
starts to leave.

> GLENN
> Whatever, I don't care. I told you I'm
> with Chris. If that makes no difference
> to you, well, that's on you.

> PEREZ
> I am not with Chris.

> GLENN
> That's not what I asked. I asked if you
> slept together.

Perez considers carefully.

> PEREZ
> No.

> GLENN
> No? No! Are you kidding *me*?! I don't
> believe you. Why wouldn't you have just
> told me that in the first place? Why
> would you put us through all this?

> PEREZ
> Whatever, just tell me what's wrong with
> Chris.

Glenn examines Perez, eyes narrowing.

> GLENN
> None of your business.

Marty approaches Kiko.

> MARTY
> I know you.

> KIKO
> What?

> MARTY
> I think I saw you at a party.

> KIKO
> Oh... where was this at?

> MARTY
> Oh, I don't know. This wasn't in real
> life.

> KIKO
> What?

> MARTY
> I saw you on somebody's page or
> something.

> KIKO
> Wow. So you think one of your friends
> posted a picture of me?

> MARTY
> Yeah. Is that weird or something?

> KIKO
> Not weird, I just thought we had
> actually met.

> MARTY
> Well now we have... and in real life.
> I'm Marty.

Marty extends a hand.

> KIKO
> Kiko.

They smile awkwardly at each other for a moment.

> KIKO
> So... see you on the internet, I guess.

Kiko moves to leave.

 MARTY
I didn't mean to make this awkward or
something.

 KIKO
No... it's just... Don't worry about it.

Kiko starts to leave again.

 MARTY
Morgan Miller!

 KIKO
Morgan?

 MARTY
Yeah. That's my friend—Your friend—Our
friend in common who posted the—

 KIKO
You're friends with *Morgan?!* I love
Morgan! Morgan is... Morgan, right?

 MARTY
Morgan is like, my best friend.

 KIKO
He is? That's amazing. Well, I'm
surprised we haven't met.

 MARTY
Right? But now we have...

 KIKO
Yeah.

 MARTY
So maybe we could hang out some time.

 KIKO
Ah... that's was what *this* was about.

 MARTY
No. Not really. I mean... Why not?

 KIKO
Look you can friend me if you want, but
not in real life.

Marty is speechless as Kiko finally leaves.

Patterson walks in and Shae jumps up in excitement.

 SHAE
You heard me!

 PATTERSON
What?

 SHAE
I wanted you to come in, and you heard
me!

 PATTERSON
I didn't hear anything. I was right over
there. Were you calling me?

 SHAE
I was. With my mind!

 PATTERSON
Not the "telepathy" again!

 SHAE
C'mon, you know what happened the other
day. You were here. I wanted to really
test it, though, so I thought, I wonder
if I can get Pat to come in here, and I
just concentrated on it for a minute and
boom! You came in!

 PATTERSON
I needed a pen.

 SHAE
A pen?

 PATTERSON
Yes, do you have one?

 SHAE
Maybe that's how it works, you didn't
need a pen till I willed you to come in.

 PATTERSON
I needed a pen because I have to address
a letter. Do you have one?

 SHAE
I do. Let's try something.

Shae guides a somewhat unwilling Patterson to a chair and then
sits opposite, setting a pen on the floor between them.

 PATTERSON
 Ah! A pen, can I borrow that?

 SHAE
 Yes. I'm going to send it to you. I
 feel strong today. I can do this.

Shae stares at the pen. Patterson watches Shae in disbelief.

 PATTERSON
 I think it's working, I think you're
 willing me to grab the pen.

Patterson starts to lean toward the pen and Shae has to push
Patterson back.

 SHAE
 Stop. I almost had it.

Shae goes back to staring. Patterson sighs and leans back.
After a moment, Patterson digs through a pocket.

 PATTERSON
 I have a quarter you could try to move.

 SHAE
 Shhh.

Patterson jumps up, finding a pen in a different pocket.

 PATTERSON
 I had a pen the whole time!

While Shae is looking up, Patterson kicks away the pen on the
ground without Shae seeing.

 PATTERSON
 Well, shoot, I'd like to help you here,
 but I need to mail a letter.

Patterson leaves and Shae sits down disappointed. After a
moment Shae looks down, notices the pen is gone, and leaps up in
excitement.

 SHAE
 Wait, Pat! Pat! I think I willed that
 pen into your pocket!

Shae runs out.

Jody and Harjeet stare at pills in Jody's hand.

> HARJEET
> So what are these supposed to do?

> JODY
> Make you feel... euphoric.

> HARJEET
> Euphoric?

> JODY
> For lack of a better word.

> HARJEET
> I don't know.

> JODY
> How can you say no to euphoria? What's
> the downside of euphoria?

> HARJEET
> Maybe the downside is that reality might
> suck compared to euphoria, so why would
> I want to ruin reality for myself?

> JODY
> You're just afraid. Admit it.

> HARJEET
> I'm not afraid. What makes you think I'm
> afraid?

> JODY
> Because your whole life is about
> control. You're terrified of being out
> of control even for one night.

> HARJEET
> That's not true.

> JODY
> Prove it.

Jody holds up the pills.

> HARJEET
> I don't have to take those pills to
> prove it. Do I?

> JODY
> How else are you going to prove it?

Reluctantly, Harjeet takes one of the pills.

> JODY
> Okay, we both take it on three. One—

> HARJEET
> Wait!

> JODY
> What?

> HARJEET
> You're right. I am afraid of losing
> control.

> JODY
> That's good. Admitting you have a
> problem is half the battle.

Jody holds up the pill.

> JODY
> One, two—

> HARJEET
> Wait!

> JODY
> What now?

> HARJEET
> Why all the peer pressure?

> JODY
> "Just say no" if you think I'm twisting
> your arm.

> HARJEET
> But *why*?

> JODY
> I'm tired of you, okay? All your perfect
> this and perfect that. Maybe I'll like
> you better if I see you unhooked...
> uncorked... un-*you*.

After a moment, Harjeet sets the pill on the ground.

> HARJEET
> One, two, three!

Harjeet stomps on it.

Nile stares at Barrett.

> BARRETT
> You have a problem.

> NILE
> I'm not the only one.

> BARRETT
> Seriously, you're drinking way too much.

> NILE
> Your problem's much more out of hand.

> BARRETT
> What are you talking about?

> NILE
> You're hyper-critical, judgmental, and you revel in finding fault.

Barrett is stymied for a moment.

> BARRETT
> You're just trying to deflect.

> NILE
> Am I? Let's talk about my drinking then. How is it a problem?

> BARRETT
> You're starting every afternoon and drinking till you basically pass out every night.

> NILE
> That sounds quite lovely, at least to me. What *problems* has it actually caused?

> BARRETT
> It's not healthy.

> NILE
> That's it? It might affect my health somewhere in the future? I might get run over by a bus before I have to face any of that.

> BARRETT
> It will affect your work and your relationships.

 NILE
Everything's good at work. Everything's
good at home.

 BARRETT
For now...

 NILE
Again, imaginary future problems. Now
your problem on the other hand...

 BARRETT
Please, you're just trying to change the
subject.

 NILE
Unless you can tell me how my drinking
is an actual problem, I think we should
talk about your problem, which is very
real. Tell me who just got that
promotion at work?

 BARRETT
Sacha?

 NILE
Right. The positive one, the uncritical
one, the non-judgmental one.

 BARRETT
There was more to that.

 NILE
Okay, you being judgmental, did it ever
come up with Lee, before Lee left you?

 BARRETT
That's a low blow.

 NILE
I'm not the one who introduced the
subject of *our problems*.

Barrett storms out.

 BARRETT
I was only trying to help!

 NILE
Yeah, me too.

 BRITT
You down for something?

 KAGAN
I'm broke. I'm down for anything.

 BRITT
I'm tired of this nickel and dime crap.
Time to get real.

 KAGAN
Dunno what that means... but I'm in!

 BRITT
Good, I think we should use your gun.

 KAGAN
Wait... you said that was too risky. You
use a gun, you do more time, right?

 BRITT
Aren't you tired of this bottom feeding?
Don't you wish you had some real money?
Don't you wanna live large for at least
a minute?

 KAGAN
Wanting something and taking the risk
are two different things.

 BRITT
So you're not down?

 KAGAN
Not with a gun I ain't.

 BRITT
Let me use it then.

Kagan has to think about this.

 KAGAN
No.

 BRITT
What are you talking about? I'll give it
back. I thought we were friends?

 KAGAN
We're partners too. We work *together*.

128

 BRITT
 I just want to try using a gun. It's not
 your thing, and that's fine, but why
 can't I give it a shot?

 KAGAN
 Go get your own gun then. And keep an
 eye out for a new partner while you're
 at it.

 BRITT
 What's this about?

 KAGAN
 Jail time, remember?

 BRITT
 Yeah, but it'd only be me.

 KAGAN
 Right, and then what happens to me?

Britt sees Kagan's emotion here and has to reconsider.

 BRITT
 That's awful sweet. I don't know if I
 should laugh or give you a big hug.

 KAGAN
 Don't you make fun of me.

 BRITT
 Sorry. I didn't mean...

There's a long awkward pause.

 BRITT
 So... you down for something or not?

Kagan looks suspiciously at Britt.

 BRITT
 No gun.

Kagan starts to warm.

 KAGAN
 Partners?

 BRITT
 Partners.

They shake hands and smile.

Grey enters carrying light baggage. Ives is clearly sad, but
greets Grey warmly.

> GREY
> You wouldn't believe the hassle it is to
> travel last minute these days. So sorry,
> I wasn't here sooner.

> IVES
> It was awful, especially at the end. In
> a way, you're better off to remember her
> the way she was.

> GREY
> Jesus, that doesn't sound good. Still, I
> wish I had been here for you at least.

> IVES
> Thanks. I survived

> GREY
> Well. I'm here now. Hopefully I can
> help you with some stuff.

> IVES
> Like the will?

> GREY
> If you need help with that... but the
> funeral... whatever. Are you mad?

> IVES
> I'm not happy. Do you expect me to be
> happy right now?

> GREY
> No, no, of course not, sorry.

> IVES
> We should get you settled. How long are
> you here for?

Ives notices the light luggage for the first time.

> GREY
> Hey, whatever you need.

> IVES
> You booked a one-way flight?

> GREY
> Well, no.

 IVES
Then, when's your return?

 GREY
I can change that. Don't worry about
that. I just gave them a... placeholder.

 IVES
And what was that "placeholder"?

 GREY
Monday.

 IVES
Monday? Are you kidding?

 GREY
"Placeholder," remember? You are mad.
Is it because I wasn't here? I tried. I
really did.

 IVES
You tried? She's been sick for a month
and in the hospital for two weeks and
you show up the day after she dies?!

 GREY
I see where that doesn't look good.

 IVES
Doesn't look good?! Look, I've been on
an emotional roller coaster for a month
and maybe I'm just taking it out on you,
but you just wasted a trip because I do
not want to see you right now.

 GREY
You... you want me to go?

 IVES
I know you don't want to be here, so
aren't I doing you a favor?

 GREY
I don't need this hostility. I will
actually go.

 IVES
I know you will, you always do... so go.

Grey hesitates a moment then leaves. Ives sighs deeply.

Zane and Whit are sitting next to each other staring ahead at
a video screen and clicking away on controllers.

 ZANE
 I think we're addicted to video games.

 WHIT
 Speak for yourself. I can stop any time
 I want.

 ZANE
 Okay, stop now.

 WHIT
 Not now. We're almost at level six.

 ZANE
 See... addicted.

 WHIT
 I don't think you should just throw
 around that word. There are people with
 real addiction problems.

 ZANE
 We don't have jobs... We're not in
 relationships...

 WHIT
 Yeah, but we're not in an alley somewhere
 doing unspeakable things just so we can
 play another game. I mean, you can't
 O.D. on video games.

 ZANE
 I don't think drugs are the only thing
 you can be addicted to.

 WHIT
 What else is a *real* addiction?

 ZANE
 ...Alcohol.

 WHIT
 That is a drug!

 ZANE
 Oh, right. Uhh... sex.

 WHIT
 We should have that problem.

 ZANE
I don't know, I think other stuff can be
bad too.

 WHIT
Like being addicted to social media?
Oh, how terrible.

 ZANE
What about like, anorexia and bulimia?

 WHIT
Are those addictions?

 ZANE
That's my point. It doesn't matter what
you call it. If the thing controls your
life instead of you controlling it, it's
not healthy.

 WHIT
This game *does* *not* control our lives.

 ZANE
Okay, let's put it down right now and go
outside.

 WHIT
Seriously? Okay. Let's pause.

 ZANE
No pause. Just put it down. It's not
important. It doesn't run our lives,
right?

 WHIT
Right.

But they both continue playing.

 WHIT
Okay. Maybe we have a problem.

 ZANE
Right. So what do we do?

 WHIT
I don't know, but we have to figure
something out.

 ZANE
Yeah... Maybe after this game.

Shaun approaches Maine.

> SHAUN
>
> Hi.

> MAINE
>
> Shaun... I'm not trying to be mean, but
> I told you to leave me alone.

> SHAUN
>
> I don't want to. I like you.

> MAINE
>
> I know, but you know it's just not going
> to work out.

> SHAUN
>
> Why?

> MAINE
>
> Because sooner or later it's going to be
> an issue.

> SHAUN
>
> It doesn't have to be. Why does it have
> to be?

> MAINE
>
> Because you'll want to do things. You
> have money and so you're used to doing
> things: concerts and travelling and
> stuff, and you'll say, "Here, I'll pay
> for it. It's not a big deal."

> SHAUN
>
> It wouldn't be a big deal. I wouldn't
> resent you.

> MAINE
>
> Okay, but maybe I would.

> SHAUN
>
> Why would you resent me? It's just money
> to me. I'd be happy to share it with
> you.

> MAINE
>
> Don't you see how that would make me
> feel?

> SHAUN
>
> It just seems like dumb pride.

 MAINE
Easy for you to say. You don't know what
it's like.

 SHAUN
I don't, you're right, because you're
too ashamed to share what it's like, as
if it was some terrible thing you did as
opposed to some random thing you were
born into.

 MAINE
Believe me, you don't wanna know what
it's like.

 SHAUN
Maybe I don't if it makes you bitter and
prideful and blind to love.

 MAINE
What?

 SHAUN
You heard me.

 MAINE
Are you serious?

 SHAUN
Would I joke about something like that?
If you don't feel the same, that's a
good reason for us not to be together,
but all this rich—poor stuff is crap.

Maine tries to process what Shaun has said.

 SHAUN
Well?

 MAINE
It's just... a *lot*.

 SHAUN
It is, but it shouldn't be. It should be
simple.

 MAINE
You're right, it should be, but you
don't understand, it just isn't.

Maine walks off leaving Shaun broken hearted.

Clearly smitten, Slava watches Taya finish eating.

> TAYA
> Circular food is great!

> SLAVA
> Like pizza?

> TAYA
> No actual circles... rings.

> SLAVA
> Like donuts? Bagels?

> TAYA
> I was thinking about the onion rings I
> just had, but yeah, I love those too,
> that's my point. Pineapple, Cheerios,
> Fruit Loops, Funyons.

> SLAVA
> Seems like kind of a narrow group.

> TAYA
> But I like everything in the group.

> SLAVA
> What about calamari?

> TAYA
> I'm not so sure about calamari. I'm not
> sure if I've had it. It's octopus,
> right?

> SLAVA
> Squid: the ones that are kind of pointy.

> TAYA
> Squid, right. So the rings, are they
> like the suckers from the tentacles?

> SLAVA
> No. They cook the tentacles sometimes,
> but the little rings are slices of the
> main part—the head or the body—the part
> that's kind of like a... thick condom.

> TAYA
> Mmmm, you make it sound so good.

 SLAVA
Somebody told me once that calamari is *not*
always squid.

 TAYA
What do you mean?

 SLAVA
Well, calamari is expensive, so some
markets and restaurants cut up pig anus
the same way and sell it as calamari.
It's apparently about the same size and
consistency, especially when you fry it.

 TAYA
Anus? People eat *anus*?

 SLAVA
If you believe—

 TAYA
Why would you tell me that?!

 SLAVA
I don't know. We were talking about ring
food and—

 TAYA,
...And you just thought you'd tell me the
most disgusting thing you could think
of?

 SLAVA
Is it that bad? I mean there's pig anus
and maybe worse in every hot dog you've
ever eaten.

 TAYA
What is wrong with you? Are you trying
to make me puke? I just ate.

 SLAVA
No, sorry. I didn't mean to—I was just
trying—I thought you weren't even sure
if you'd ever eaten calamari.

 TAYA
Well I sure won't now and it'll be a
while on hot dogs too. Thanks.

Taya leaves disappointed. Slava's shock quickly turns to
disappointment.

Curry and Lilo huddle together on the floor looking scared and disheveled. They whisper to each other.

 CURRY
 I think we need to run for it.

 LILO
 That sounds like a good way to get
 killed.

 CURRY
 What makes you think they won't kill us
 anyway?

 LILO
 Are you trying to make this worse?

 CURRY
 They're not watching us that closely.

 LILO
 They'll let us go, we just need to do
 what they tell us.

 CURRY
 And when they put a gun to the back of
 your head and tell you to kneel down,
 will you do that too?

 LILO
 I really don't want to think about that.

 CURRY
 But you have to. You want to survive
 this, don't you?

 LILO
 Stop. I don't want to try anything
 stupid, so just stop.

 CURRY
 No. I'm sorry you're scared, but if we
 want to get out of this, we've got to be
 smart here, not be afraid.

 LILO
 Maybe you're right, okay, but it doesn't
 make me any less scared.

 CURRY
 They're not paying attention. We can do
 this. You can do this.

> LILO
> They are kind of preoccupied. What do
> you think they're doing?

> CURRY
> I don't know, maybe they're trying to
> get a ransom...

> LILO
> A ransom? If the ransom is paid, they'll
> let us go.

> CURRY
> Who's going to pay your ransom?

> LILO
> I don't know, the police? The
> government?

> CURRY
> Yeah, I don't think it works that way.
> And even if somebody does pay, once they
> have the ransom—we've seen their faces,
> we're witnesses—it's better for them to
> just kill us anyway.

> LILO
> Is that true?

> CURRY
> Yeah. Sorry. Now you see why we've got
> to do this.

They make eye contact and Lilo nods "yes."

> CURRY
> Good. We're going to edge over to that
> door while they're not looking and once
> we're there, we're going to run for it.

They both look up, waiting.

> CURRY
> Okay, here we go.

Curry starts to slide, but Lilo doesn't move. Curry tries to
catch Lilo's eye, but Lilo just looks down afraid and ashamed.

Curry starts to scoot away again, but stops and looks at Lilo
again, torn. After a long moment, Curry scoots back to Lilo.
Silently Lilo leans into Curry, comforted. Curry sighs.

Griffin looks around and then walks up to Shou.

> GRIFFIN
> Oh, hey, sorry to bother you. I just
> wanted to warn you that I heard there
> was some kind of cell phone scam going
> on, so be careful.

Griffin starts to leave.

> SHOU
> What kind of scam?

> GRIFFIN
> Oh, some kind of deal where the scammer
> just gets the sucker to hand over their
> phone. I don't know all the details.

> SHOU
> Who would just hand over their phone?

> GRIFFIN
> Right? They must be good.

> SHOU
> Maybe they pretend it's an emergency or
> something?

> GRIFFIN
> That could work especially if they look
> clean-cut and are good at acting scared.

> SHOU
> I don't think there's anything a
> stranger could say to make me give up my
> phone.

> GRIFFIN
> Then you've got nothing to worry about.
> I tell you what, let's test you out.
> I'll pretend to be a stranger, okay?

> SHOU
> You are a stranger.

> GRIFFIN
> Ha, ha, even better, right? Griffin by
> the way.

> SHOU
> Shou.

Suddenly, Griffin changes demeanor dramatically going from
charm to panic. It startles Shou.

> GRIFFIN
> Can you call 911 for me? My friend fell
> off a path and hurt his head. He's
> bleeding bad. Oh my God! Please call.

Griffin winks and Shou starts to enjoy the game, pulling out a
phone.

> GRIFFIN
> Just pretend to call.

> SHOU
> Right... Uh... nine... one... one. It's
> ringing. What should I tell them?

> GRIFFIN
> Uh... They need to hurry! I don't know
> how to stop the bleeding!

Griffin starts to run off.

> SHOU
> Wait, wait! Where's your friend!?

> GRIFFIN
> He's on the beach, you know the private
> part where you have to enter off of that
> access gate on Ocean Drive? Do you even
> know this area!?

Shou looks puzzled and overwhelmed and Griffin extends a hand
to take the phone. Shou instinctively starts to extend the
phone, but pulls it back.

> SHOU
> Hold on, they're answering.

Griffin falls out of character and looks puzzled.

> SHOU
> Hello, nine-one-one? You know that cell
> phone scam? I just had a run-in with the
> thief and can give you a positive ID...
> No, ran off I'm afraid, but might still
> be in the area.

Griffin shares a smile of admiration with Shou then promptly
runs off.

Tig approaches Stef.

> TIG
> Who you been talking to?

> STEF
> What does that mean?

> TIG
> People seem to know my business that
> shouldn't know my business. Somebody got
> to be talking.

> STEF
> Not me.

> TIG
> How can I know that?

> STEF
> You know me. You've known me a long
> time. That should be enough.

> TIG
> I've known a lot of people a long time.
> Somebody's still talking.

> STEF
> Not me. You know that.

> TIG
> Yeah. I'd like to think that.

> STEF
> I'm telling you.

> TIG
> You know what they say about snitches.

Stef bristles at this.

> STEF
> Are you... threatening me?

> TIG
> I'm just saying...

> STEF
> Just saying what?

> TIG
> I want things to stay good between us.

 STEF
Things have always been good between
us... until now.

 TIG
I've got a problem and you can help me
with it or you can add to it.

 STEF
I am no part of your problem and you can
have my help or you can make a brand new
problem out of me.

 TIG
Taking all this hard?

 STEF
No other way to take it.

 TIG
I'll back off, just don't let me hear
you been talking.

 STEF
You need to quit with that talk.

 TIG
Or what?

 STEF
Or we're gonna go round.

 TIG,
Oh yeah?

 STEF
I got respect for you, but *you* don't
accuse me and *you* don't threaten me.
Understand?

 TIG
Wow. I never seen this side of you.

 STEF
You always been on my good side.

 TIG
I'll try to stay there then. Respect.

Tig puts out a hand and after a moment, Stef shakes it.

Atherton walks in distraught and sees Gene reading. Atherton
hesitates for a long moment before approaching.

> ATHERTON
> Can we talk?

Gene looks up after a moment and can tell something's wrong.

> GENE
> Crap! What is it?

> ATHERTON
> I need to tell you something.

> GENE
> Are you okay? You look okay. Is Riley
> okay?

> ATHERTON
> Not exactly.

> GENE
> Oh my God! Was it an accident?

> ATHERTON
> We separated.

Gene looks confused.

> GENE
> Who?

> ATHERTON
> Me and Riley.

> GENE
> No way.

> ATHERTON
> Yes.

> GENE
> You and Riley are perfect. What are you
> talking about?

> ATHERTON
> We separated, okay? You're not making
> this easy.

> GENE
> Am I supposed to make this easy?

 ATHERTON
Gene, this happened to me. You
understand that, right?

 GENE
It happened to everybody. Now we all
have to choose sides. Somebody's getting
unfriended.

 ATHERTON
My heart's broken. Can you put this in
perspective?

 GENE
I'm sorry, you're right. What happened?

 ATHERTON
I don't love you anymore. That's what
Riley said.

 GENE
No.

 ATHERTON
What do you mean "no"?

 GENE
Not possible.

 ATHERTON
Are you not listening? This happened.

 GENE
Not Riley?

 ATHERTON
Yes, Riley.

 GENE
Do I have to unfriend Riley now? I love
you both.

 ATHERTON
That's nice, but this is not about you!

 GENE
Yes, yes. I'm sorry. You're right. I'm
here for you.

 ATHERTON
Good, and yes, you have to unfriend
Riley.

 MARS

I think it would be great to see the
pyramids, something... permanent, right?

 DANA

Permanent? What are you getting at?

 MARS

You know... things and people are all
so... transitory. It would be nice to
see something that is here, like, for
good... permanent, right?

Dana looks Mars over for a moment before responding.

 DANA

Well, I've got bad news for you, the
pyramids are not permanent. They're
older than us, yeah, and they'll outlast
us, yeah, but that's not saying much.
They haven't even been around a second
on the cosmic calendar and they'll be
sand again in another cosmic second.

 MARS

That's nice.

 DANA

Sorry, it's true, though. Nothing on
this sorry planet is permanent, not even
the atoms the place is made out of.

 MARS

Okay, so whatever, nothing's permanent,
so why even try, right?

Mars starts to leave.

 DANA

It's okay to try.

 MARS

What?

 DANA

I mean permanence is an illusion, but we
have the concept for a reason. It's
like perfection, it doesn't really exist,
but it gives us something to aspire to.

 MARS
I like that better.

 DANA
People need ideals to aspire to or they
wouldn't know what to do.

 MARS
So... you're okay with permanence?

 DANA
The pyramids are beautiful, of course,
and partly because they represent
someone's aspiration to create something
permanent.

 MARS
Right! That is beautiful!

 DANA
Except, of course, that they're already
crumbling, proving the vanity of ever
aspiring to permanence.

 MARS
Seriously?

 DANA
Are they not crumbling?

 MARS
Whatever... You're exhausting. You're
not as smart as you think you are.

 DANA
If I was smart, I just would have said,
yeah, the pyramids are awesome. They are
permanent, let's go see them.

 MARS
Oh, you didn't say that because you're
not smart.

 DANA
Okay, why didn't I say it then?

 MARS
Because you're *afraid* of something...
permanent.

Mars smiles as Dana is unable to respond for once.

147

Azmi and Scout are lying on their backs staring up into the
night sky.

> AZMI
> That is a crap-ton of stars.

> SCOUT
> It's called the Milky Way. You can never
> see it in the city because there's too
> much other light.

> AZMI
> What do you think of when you look at
> all those stars?

> SCOUT
> Well... I was in Paris and I went to this
> thing called the catacombs where there's
> like a million bones stacked up in these
> tunnels. They moved them all there after
> they put condos or something where the
> graveyards used to be. And I remember
> looking at all those skulls and thinking
> those were all people, just like me,
> with hopes and dreams and fears and
> insecurities.

> AZMI
> The stars make you think of skulls?

> SCOUT
> Well, you know, all our efforts, all our
> worries... it puts them in perspective.

> AZMI
> So they make you feel... insignificant?

> SCOUT
> Sort of, but that sounds negative, when
> I think it's kind of freeing.

> AZMI
> Stop worrying because your life really
> is less than crap in the scope of the
> universe?

> SCOUT
> Something like that. I think you're
> having a little fun with me... but it's
> cool.

They both go back to staring up for while.

> SCOUT
> What do you think of?

> AZMI
> I think of you.

> SCOUT
> Me?

> AZMI
> ...And your crazy, stupid catacombs story.

> SCOUT
> Shut up. C'mon, really?

> AZMI
> It's kind of true, actually. I dig this,
> but I would never come out here for this
> on my own.

> SCOUT
> So stars make you think of me bringing
> you to see the stars?

> AZMI
> I mean, stuff like this is only good if
> you can share it.

> SCOUT
> I get it. That's really nice...

They both go back to staring up for while.

> AZMI
> Share it... with the right person.

> SCOUT
> Are you getting sentimental on me?

> AZMI
> Stars and skulls, you know... puts things
> in perspective.

They chuckle.

> SCOUT
> Yeah...

Scout reaches out and takes Azmi's hand. Azmi looks down, but
Scout just keeps staring up. Azmi smiles and looks back up.

149

Asia and Garland sit quietly next to each other.

 ASIA
 We're going to have to talk about
 things.

 GARLAND
 Oh, is this *the* talk?

 ASIA
 The old man left some money, but he left
 things in a mess. We're going to have to
 figure some things out.

 GARLAND
 Of course, you're the responsible one,
 gotta talk about the important things.

 ASIA
 Seriously, there are big issues. Do we
 sell the apartments, the bar?

 GARLAND
 You don't care what I think. You know
 what you think needs to be done. Just do
 it. Don't pretend to care what I think.

 ASIA
 That's not how it is.

 GARLAND
 Oh yeah? Tell me honestly that you
 don't already have a plan in mind.

This stops Asia for a moment.

 ASIA
 That's not the point. We need to do this
 together.

 GARLAND
 Why?

 ASIA
 It's what he wanted. He was clear about
 that.

 GARLAND
 Is that true?

 ASIA
Yes. We spoke about it, just before...

 GARLAND
He wanted *me* involved in *his* business?

 ASIA
Yes. You're still family.

 GARLAND
Will you be honest with me?

 ASIA
Okay.

 GARLAND
Do *you* want me involved in any of this?

Asia hesitates picking words carefully.

 ASIA
We're still family. We'll find a way to
make things work. I think this can be
good for you.

 GARLAND
That's really nice. It does mean
something to me, but you're the
responsible one and I do trust you.

 ASIA
Thanks, but I still need your help. Will
you help me?

 GARLAND
You need *my* help? Or is this also part
of what he told you to do?

Garland considers carefully.

 ASIA
Both. Please, give it some serious
thought. I'm sincere. Please help me.

 GARLAND
I... I guess I could give it a chance.

Asia smiles, extending a hand. Garland hugs Asia instead.

 GARLAND
Still family...

Peale storms in and Bettany jumps up, dodging around the room.

> BETTANY
> Whoa! Take it easy!

> PEALE
> I'll take your head off easy.

> BETTANY
> No. You're mixed up about all this.

> PEALE
> You weren't out with Harper? Everyone
> saw you.

> BETTANY
> I was, but it wasn't like a date.

> PEALE
> What was it like then?

> BETTANY
> Harper just wanted my advice.

> PEALE
> About what?

> BETTANY
> You. About your temper. How to deal
> with it. It's scary.

Peale is slowed by this.

> PEALE
> I... I don't believe you. It's too...
> ironic.

> BETTANY
> It's not so much ironic in this
> circumstance. It's part of a pattern.

> PEALE
> I still don't believe it.

> BETTANY
> Call Harper.

Peale pulls out a phone and hits a number on speed dial.

> PEALE
> Hi... Yeah... Over at Bettany's...
> Actually yeah... That's what Bettany
> said...

Peale covers the phone, and extends it to Bettany.

> PEALE
> Harper wants to talk to you.

Bettany is still a little wary of Peale, but grabs the phone.

> BETTANY
> Yeah... Oh yeah... Okay, but pretty
> shaken up... I know, right? Yeah, scary...
> Like a wild animal or something...

Peale listening anxiously, motions for Bettany to cover the
phone.

> BETTANY
> Just a second.

Bettany covers the phone and Peale speaks.

> PEALE
> Take it easy.

> BETTANY
> Why should I?

> PEALE
> I never would've hurt you. I'm sorry if
> I scared you. I was never like this
> before. I used to be calm... easy going.
> I'm just so crazy about Harper, you
> understand?

Bettany gets back on the phone as Peale looks pleadingly.

> BETTANY
> Harper? Yeah... Look, I'm fine
> actually... I think it was mostly
> show... Peale's literally crazy about you,
> you know that? Right... The anger thing
> will have to be worked on though...

Peale smiles and nods solemnly in agreement.

> BETTANY
> Alright... Talk to you.

Bettany tries to hand the phone back, but Peale begins hugging
Bettany enthusiastically.

> BETTANY
> Take it easy.

Mandeep approaches Gibson who is seated.

> MANDEEP
> Is that my bag?

> GIBSON
> What?

Mandeep points to a bag at Gibson's feet.

> MANDEEP
> That bag. It's mine.

> GIBSON
> I don't know what you're talking about.
> That's my bag.

> MANDEEP
> That's my bag. It was stolen. If it's
> yours, where'd you get it?

> GIBSON
> That's none of your business. I don't
> know you.

> MANDEEP
> That's about the response I'd expect.

> GIBSON
> I'd like you to leave me alone.

> MANDEEP
> Fine, then give me back my bag.

Gibson picks up the bag and holds it tight.

> GIBSON
> Stop it. It's not your bag.

> MANDEEP
> Let me look inside.

> GIBSON
> Are you crazy? I'm not letting you look
> in my bag.

> MANDEEP
> Still got my stuff in it?

> GIBSON
> It has my stuff in it and I'm not
> letting you root around in it.

 MANDEEP
 You can hold onto it. Just hold it open
 and let me look inside. No touching.

 GIBSON
 Are you serious? Will you leave me alone
 if I do?

 MANDEEP
 Sure.

Gibson holds the bag open and Mandeep steps closer, leaning
over and peering into the bag.

 MANDEEP
 So why do you carry around an empty bag?

Gibson snaps the bag closed and backs away from Mandeep.

 GIBSON
 This is insulting. You need to leave me
 alone or I'm going to call the cops.

 MANDEEP
 Now you're talking. Call the cops, I
 dare you.

 GIBSON
 Why don't you call them?

 MANDEEP
 Because my phone was in that bag.

 GIBSON
 That sucks for you, but it wasn't this
 bag. I showed you the inside, you said
 you would leave me alone.

 MANDEEP
 Don't wanna call the cops, huh?

 GIBSON
 Whatever, I never liked this bag,
 anyway. Enjoy it.

Gibson tosses the bag toward Mandeep and leaves.

 MANDEEP
 What did you do with my stuff?!

Mako walks in and finds Ronson sitting.

> MAKO
>
> Ah, good. I wanted to talk to you.

> RONSON
>
> Oh? What is it?

> MAKO
>
> Well, there have been some complaints.

> RONSON
>
> Complaints? About *me*?

> MAKO
>
> Yes.

> RONSON
>
> From who?

> MAKO
>
> Customers. I've been hearing that you could be more polite and—

> RONSON
>
> Can you be more specific?

> MAKO
>
> I said, *polite*.

> RONSON
>
> What specifically did I do that was not polite—that a customer complained about?

> MAKO
>
> That's not really the point here.

Ronson maintains a calm, friendly tone.

> RONSON
>
> Isn't the point for me to avoid whatever I had done that was seen as impolite by a *customer*? How can I do that if I don't know what that specific behavior was? That is the point, isn't it?

> MAKO
>
> I feel like you're not taking this the right way—in the constructive spirit it was intended.

 RONSON
Constructive? How is something this
vague constructive?

 MAKO
If a customer says something to me, I
need to listen, I can't interrogate
them, that would be inappropriate.

 RONSON
I don't know. You're the manager. I
think maybe it is appropriate for you to
get to the bottom of an issue before you
start throwing around accusations.

 MAKO
Are you telling me how to do my job?

 RONSON
No... but I think you should know...
there have been some complaints... about
you—and they are quite *specific*. It
seems the employees here all feel that
you use vague and *undocumented*
customer complaints as a way to
intimidate and control us.

 MAKO
So I need to get a complaint from a
customer in writing before I can talk to
you about it?

 RONSON
If you want to avoid any *specific*
complaints *in writing* yourself, then
yes, I think you do.

 MAKO
You seemed like a great employee, but
clearly you have an attitude issue,
apparently a problem with authority.

 RONSON
No, nothing that vague, I have a problem
with this specific thing you have done.
Don't you understand that difference?

Ronson looks Mako in the eye a long moment, then turns to go.

 RONSON
I have to get back to work.

Hardey runs in and finds Taylor pacing anxiously.

> HARDEY
> Are you okay?

> TAYLOR
> I don't know. I'm... struggling.

> HARDEY
> I thought you were doing good. I thought
> you were over the hump.

> TAYLOR
> That doesn't mean it's all over. There's
> a reason people relapse.

> HARDEY
> Of course, of course. I just meant—

> TAYLOR
> I know. I didn't mean to snap. Sorry.
> Thanks for coming.

> HARDEY
> No worries. How can I help?

> TAYLOR
> Just, I guess... be with me.

> HARDEY
> Can do.

Hardey sits down and watches Taylor pace for a while.

> HARDEY
> Anything happen? ...To like... set you
> off... or whatever?

> TAYLOR
> That's not always how it works.

> HARDEY
> Sure, but you've been clean for like a
> month haven't you? Nothing happened?

> TAYLOR
> What makes you so sure something
> happened?!

 HARDEY
 Hey, sorry. I thought it was maybe
 something I could talk you through. I'm
 here to help, right?

 TAYLOR
 Right. I know. Look, something did
 happen.

 HARDEY
 What?

Taylor pauses a long moment.

 TAYLOR
 I heard about you and Terry.

 HARDEY
 Oh. Was that a problem for you? You and
 I broke up a long time ago.

 TAYLOR
 It shouldn't bother me, I know.

 HARDEY
 Then what's going on?

 TAYLOR
 I'm realizing there's a part of me that
 thought maybe we could get together
 again if I could just clean up.

 HARDEY
 Wow. I guess... I'm sorry.

 TAYLOR
 Don't be sorry. I was lucky to have that
 to think about. It got me through rehab,
 really. It's more than a lot of people
 have. I'm lucky you're here now.

 HARDEY
 I'm glad to be here, but what can I do?

 TAYLOR
 Just be with me.

 HARDEY
 Can do.

Hardey smiles and extends a hand to Taylor. After a moment,
Taylor takes Hardey's hand and finally sits.

Macy and Coz huddle in a corner.

 COZ
 Hairy out there today.

 MACY
 No doubt. I was glad to have someone
 with me.

 COZ
 Yeah. Me too.

There is an awkward pause.

 COZ
 Look, I don't mean to be rude, but I
 don't know you very well and things
 got close out there.

 MACY
 So?

 COZ
 How do I know you didn't get bit?

 MACY
 What are you talking about?

 COZ
 You might, you know, turn into one, if
 you got bit.

 MACY
 Are you thinking these are like zombies,
 from a movie?

 COZ
 What are they then?

 MACY
 This is some kind of disease, it's not
 the dead rising from their graves.

 COZ
 Well, you may be thinking of the early
 zombie canon where the zombies were
 always re-animated corpses, but there
 were many later variations where it was
 more of a disease scenario.

 MACY
 So you were into those movies?

 COZ
...And shows. Kind of ironic, right?

 MACY
Yeah. So... how do you defeat zombies in
movies?

 COZ
In movies, they're kinda easy to kill.
Any kind of headshot does the trick:
gun, club, bat, shovel... It kind of
became a thing to come up with new ways
to kill zombies in movies.

 MACY
I didn't mean kill one, I meant defeat
them all.

 COZ
Oh... Actually, survival's kind of the
best you can hope for. Zombies are never
wiped out—strength in numbers.

 MACY
Oh.

 COZ
These aren't zombies, though, right?

 MACY
Right.

Another awkward pause.

 COZ
You didn't get bit, did you?

 MACY
No.

 COZ
Good. Better safe than sorry, right?

 MACY
Sure.

 COZ
We good?

 MACY
Glad to have someone with me.

Bosch storms in incensed. Payton remains calm.

> BOSCH
> They raised the rent again!

> PAYTON
> Well, they own the property, they set the rates, right?

> BOSCH
> It's just greed, pure and *simple!* They know there's not enough housing and nobody's got any options around here.

> PAYTON
> Yeah, that's called supply and demand.

> BOSCH
> What are you an economist *now?!* I call it gouging!

> PAYTON
> I suppose you could, but still, you either stay and pay it or go find a different place.

> BOSCH
> So we should just take this?!

> PAYTON
> Do you think we can do anything that would keep them from raising the rent?

> BOSCH
> They just raised the rent last year!

> PAYTON
> Do prices ever go down?

> BOSCH
> Why are you so calm about this?

> PAYTON
> What can I do about it? What can being angry do about it?

> BOSCH
> Make them reconsider their greed maybe.

> PAYTON
> Make them find new tenants more likely.

 BOSCH
 You're right in a way, how much can I
 blame them, they're just maximizing
 their profits, right?

 PAYTON
 ...The American way.

 BOSCH
 You... You're so apathetic and so
 complacent, you're the real problem.

 PAYTON
 Me?

 BOSCH
 You're a sheep. You make these wolves
 possible!

 PAYTON
 C'mon now, I didn't raise the rent.

 BOSCH,
 But you don't care! Otherwise these
 bastards couldn't get away with this.

 PAYTON
 I didn't say I didn't care. I only said
 it's not worth getting upset about. If
 you get upset, they win, right?

 BOSCH
 How?

 PAYTON
 They can take away your money, but don't
 let them control you emotionally. Take a
 few breaths.

 BOSCH
 Maybe you're right.

 PAYTON
 I heard it was only five bucks.

 BOSCH
 That's not the point!

 PAYTON
 Deep breaths, remember?

Bosch tries to calm down as Payton sighs quietly.

Brady walks in on Gabriel.

> BRADY
>
> You haven't heard yet, have you?

> GABRIEL
>
> Heard what?

> BRADY
>
> I was hoping I wouldn't be the one to
> have to break this to you.

> GABRIEL
>
> What? You're scaring me. Is everyone
> okay?

> BRADY
>
> It's Mom and Dad—

> GABRIEL
>
> Oh my God!

> BRADY
>
> They're okay—sort of. They're getting a
> divorce.

> GABRIEL
>
> A divorce? Mom and Dad? Where did you
> hear this?

> BRADY
>
> Mom called me.

> GABRIEL
>
> She called *you*?

> BRADY
>
> I'm sure she'll call you soon.

> GABRIEL
>
> Whatever... You didn't hear from Dad,
> though, just Mom?

> BRADY
>
> Where are you going with this?

> GABRIEL
>
> I think maybe this is something Mom is
> thinking, not something that's actually
> happening. You know how she is.

 BRADY
 Do you think I'm stupid or something? I
 spoke to her.

 GABRIEL
 Okay, but I'm going to call Dad.

Gabriel pulls out a phone.

 BRADY
 Wait. Don't you want to know what
 happened?

 GABRIEL
 Dad can tell me.

 BRADY
 He might not. See... he cheated on Mom.

 GABRIEL
 You're a liar... or Mom's a liar, I don't
 know, but Dad would never do that. I'm
 calling him.

Gabriel starts dialing the phone.

 BRADY
 He did it.

 GABRIEL
 Always taking Mom's side.

 BRADY
 I've known about it for a *while*... Mrs.
 Brown... the one from down the block...
 ever since Mom was in the hospital.

Gabriel lowers the phone.

 GABRIEL
 Are you serious? You knew? How could
 you not say anything?

 BRADY
 I couldn't. I couldn't do it to Mom,
 especially during her recovery, but
 mostly... I couldn't do it to you, not
 with the way you feel about Dad.

Brady puts a hand on Gabriel's shoulder, but Gabriel brushes
it off and marches away silently. Brady sighs.

Demeter and Bentley smile at each other awkwardly.

> BENTLEY
> Wow. So this is it. After two years,
> this is it.

> DEMETER
> Twenty-nine months.

> BENTLEY
> Isn't that two years?

> DEMETER
> Almost two and half.

> BENTLEY
> Right, *sorry*.

> DEMETER
> No need to get snarky now.

> BENTLEY
> You're right. We're doing the right
> thing, though, that's obvious.

> DEMETER
> Trying to reassure yourself?

> BENTLEY
> I think I'm the one that's certain.

> DEMETER
> Rub it in, why don't you.

> BENTLEY
> I didn't mean—This is hard, right?
> Harder than I thought.

> DEMETER
> I knew it would be hard for me.

> BENTLEY
> We should focus on the good times,
> right?

> DEMETER
> If I do that, I won't want to go through
> with this.

> BENTLEY
> C'mon, it's for the best.

> DEMETER
> Is it?

> BENTLEY
> Are we going to do this again?

> DEMETER
> No. Sorry.

> BENTLEY
> Don't be sorry. No apologies, no
> regrets, right?

> DEMETER
> Right... No regrets.

> BENTLEY
> Don't make this harder than it already is.

> DEMETER
> Do you think I'm trying to make this
> harder?

> BENTLEY
> I really don't know how to do this. Do
> you? Maybe we should just get it over
> with.

Bentley extends a hand. Demeter stares at it.

> DEMETER
> Wow, a handshake?

> BENTLEY
> Sorry, you're right.

Bentley gestures for a hug.

> DEMETER
> Whatever, I think I'm starting to get
> over this now. Goodbye.

> BENTLEY
> Okay then, goodbye.

Bentley starts walking out, but hesitates for a moment.

> DEMETER
> Goodbye.

Bentley continues out. Demeter collapses.

Carson and Iku sit silently. Carson broods.

> CARSON
> This isn't fun anymore.

Iku looks up, surprised.

> IKU
> What do you mean?

> CARSON
> Something's changed.

> IKU
> What?

> CARSON
> Something... Who knows exactly with
> these kinds of things, but it's not the
> same, is it?

> IKU
> I don't *know*. There are ups and downs,
> aren't there?

> CARSON
> You're an optimist. I always liked that
> about you, but it's over. We need to
> recognize that.

> IKU
> Okay.

> CARSON
> Okay?

> IKU
> Yeah. If that's the way you feel.

> CARSON
> I expected you to... at least care a
> little more.

> IKU
> I care, but if this is your attitude,
> I'm not going to beg you or something.

> CARSON
> It's not my "attitude." It's just a
> fact. Something's changed.

> IKU
> Whatever, you're just trying to act like
> this isn't on you somehow.

> CARSON
> So you're saying *nothing* changed?

> IKU
> Oh, something changed... *you.*

Carson processes.

> CARSON
> *We* didn't change? *You* didn't change?

> IKU
> Do you think *I* changed?

> CARSON
> Maybe not, but something changed between
> us. I'm sure of that.

> IKU
> Look. If it's easier for you to think
> about it that way, it's fine by me.

> CARSON
> I'm kind of surprised you're taking it
> this way. Are you mad?

> IKU
> I'm disappointed. I thought more of you.

> CARSON
> Ouch. Really?

> IKU
> You made me believe you were serious,
> that you were committed, but at the end
> of the day you're out because it's "not
> fun anymore." Yeah, I'm disappointed.

> CARSON
> I don't know what to say.

> IKU
> How about, "goodbye."

Carson is speechless as Iku stalks out.

> CARSON
> Wow. Talk about not fun.

Vic and J.C. walk in laughing.

> VIC
>
> It's been amazing seeing you again.

> J.C.
>
> Right? So much fun!

> VIC
>
> You know, I kind of worried about what it would be like if I ever ran into you.

> J.C.
>
> You did? Why?

> VIC
>
> I don't know, I worried it would be awkward...

> J.C.
>
> I can see that.

> VIC
>
> What did you think it would be like to see me again?

> J.C.
>
> I don't know.

> VIC
>
> You never thought about it?

> J.C.
>
> *Oh, I thought about it.*

> VIC
>
> What does that mean?

> J.C.
>
> I didn't mean for that to come out like that.

> VIC
>
> Well, it's out now.

> J.C.
>
> Well, I sort of fantasized about running into you for a long time—until I met Alex, of course.

> VIC
>
> Of course. What happened?

 J.C.
When I met Alex?

 VIC
No, in the fantasies.

 J.C.
Oh... We are not going there.

 VIC
That's too bad.

Pregnant pause as they stare into each other's eyes, but Vic
breaks eye contact.

 J.C.
So... you thought it would be awkward...
What did you think might happen?

 VIC
Oh gosh, I suppose I kind of thought I
might throw myself at you and you would
probably... reject me.

 J.C.
You would not have *thrown* yourself at
me.

 VIC
I don't know, there were a lot of times
I think I would have.

 J.C.
...Had you run into me at the right time?

 VIC
Oh yeah.

 J.C.
But you got over it?

 VIC
Kind of. Did you? Get over... those
feelings?

Vic moves close to J.C. and there is a long moment of
connection where J.C. is clearly tempted, but J.C. turns
away at the last minute.

 J.C.
Alex, remember?

Hawkins is studying Schuyler closely as Schuyler reads.

 HAWKINS
 The police haven't talked to me. Have
 they talked to you?

 SCHUYLER
 About Devon? No, at least not yet.

 HAWKINS
 That's surprising, I mean, you might
 even be a possible suspect.

 SCHUYLER
 Thanks. Really?

 HAWKINS
 No offense, I just mean I see where they
 might see you as a suspect.

 SCHUYLER
 Well, I don't and so far neither do the
 police.

Hawkins hesitates.

 HAWKINS
 Maybe they don't know about the whole
 thing that went on with Devon and Jan
 yet.

 SCHUYLER
 What does that have to do with me?

 HAWKINS
 I know about you and Jan.

 SCHUYLER
 I don't know what you're talking about.

 HAWKINS
 Yeah, I kind of knew you'd deny it, so I
 checked your phone and saw the texts.

 SCHUYLER
 Oh my God, are you spying on me? You
 looked at my phone?!

 HAWKINS
 There are bigger issues here than your
 privacy. Devon's dead.

> SCHUYLER
> I didn't have anything to do with that.

> HAWKINS
> Then where were you Wednesday night?

> SCHUYLER
> Do you think I killed Devon? How could
> you think that about me? You've known me
> practically my whole life.

Hawkins thinks a moment and lightens up.

> HAWKINS
> You're right, I've just read too many
> detective novels or something. I let
> myself get carried away... Still, you
> can see where the police might have
> some questions about this.

> SCHUYLER
> Maybe. Depends on what Jan tells them—
> and maybe you now too.

> HAWKINS
> So what will *you* tell them? ...About
> Wednesday night?

> SCHUYLER
> I was here... alone.

> HAWKINS
> Was your phone here too? They can check
> the phone records and know where you
> were, you know that?

> SCHUYLER
> I... might have been out for a while. Is
> that true? Can they do that?

> HAWKINS
> Too many detective novels, remember?

Hawkins starts to leave.

> SCHUYLER
> Wait, if I were in one of those
> detective novels, what would I do?

> HAWKINS
> Get a lawyer.

Tandy walks in on Kincaid.

> TANDY
> I need to give you my two-week notice.

> KINCAID
> What...?

> TANDY
> I'm quitting, sorry.

> KINCAID
> This seems so sudden. Is everything
> okay?

> TANDY
> Yeah, fine. I'm just leaving, not dying.

> KINCAID
> But I didn't know you were thinking
> about... I mean, were you unhappy?

> TANDY
> Do you have to be unhappy to leave a
> job?

> KINCAID
> No. I just thought... I don't want to
> see you go—the company doesn't.

> TANDY
> I don't think the company gives a damn,
> but I was wondering how *you'd* feel about
> me leaving?

> KINCAID
> I hate to lose a great employee.

> TANDY
> That's the only reason you don't want me
> to go?

> KINCAID
> I... I... What are you getting at?

> TANDY
> I've seen you looking at me.

Kincaid is speechless for a moment.

 KINCAID
Is that what this is about? Have I made
you uncomfortable somehow?

 TANDY
In a way.

 KINCAID
Well, I apologize if I have. That was
never my intention.

 TANDY
Why were you looking?

Kincaid is flustered.

 KINCAID
Is this a sexual harassment thing or
something?

 TANDY
No, relax. You didn't cross any lines,
but... why were you looking?

 KINCAID
Well... I find you... attractive.

 TANDY
That's great. That's what I was hoping,
because the feeling is—as they say—
mutual.

 KINCAID
It is?

 TANDY,
That's why I decided to quit. I know
you're pretty big on the rules.

 KINCAID
...And employees aren't allowed to date.

 TANDY
Right, so...?

 KINCAID
So... two weeks?

 TANDY
Two weeks.

Tandy leaves smiling and Kincaid nearly bursts with happiness.

COLSON
I've gotta run some errands. Anything I
can do for you while I'm out?

MARTY
That's nice, but no.

Colson starts to go. Marty sighs deeply.

MARTY
I'm not in love with you.

COLSON
What?

MARTY
I know why you're always trying to do
stuff for me.

COLSON
I like to do things for you.

MARTY
I know, but I'm saying I don't feel the
same way about you, so stuff like this
feels like I'm taking advantage of you.

COLSON
How are you taking advantage if it's me
offering to do stuff?

MARTY
Why do you want to do it?

COLSON
I... like you so I like doing things for you.

MARTY
"Like"?

COLSON
You know how I feel.

MARTY
Exactly. That's why I can't let you do
stuff. It's like I'm giving you false
hope or something.

COLSON
What are you talking about? I just like
helping you. It makes me feel good.

 MARTY
 Sorry, but you really need to move on.

 COLSON
 What do you mean?

 MARTY
 Find someone else to fall in love with
 and do nice things for *them*.

 COLSON
 I... don't think it works that way.

 MARTY
 It works that way. Unrequited love is a
 thing, and you're hardly the first to
 suffer from it.

 COLSON
 So you want me to leave you alone?

 MARTY
 I... didn't exactly say that. I like you,
 but I'm telling you, don't hang around
 on the hope that I'll fall in love with
 you, okay?

 COLSON
 How do you know for sure that you won't?

 MARTY
 That's impossible to say, but if I'm not
 in love now, it's probably not happening,
 don't you think?

 COLSON
 I don't think that's how it works at
 all. There's love at first sight, but
 then there's those people who know each
 other a long time and then...

 MARTY
 You're really betting a long shot here...

Colson shrugs and Marty considers for a long moment.

 MARTY
 Pick me up a pizza then, I guess.

Colson leaves smiling.

Ula and River are walking when River stops.

 RIVER
 We're lost.

 ULA
 We're not lost.

 RIVER
 Where are we then?

 ULA
 We're on a trail. How can we be lost if
 we're on a trail?

 RIVER
 But what trail are we on?

 ULA
 The trail to the lake. You saw the sign
 at the trail head, didn't you?

 RIVER
 Yeah, but there were those forks and the
 trail crossings.

 ULA
 I'm sure we're fine.

 RIVER
 Let's check.

 ULA
 There's no way to check.

 RIVER
 Let's look at the trail map.

 ULA
 It's not going to tell us where we are.
 It's a map. It doesn't have GPS.

 RIVER
 But we can look for the forks and the
 trail crossings and maybe figure out
 where we are.

 ULA
 I don't see the point.

> RIVER
> Just give me the trail map. It can't hurt
> to look.

> ULA
> Yeah. I don't have the trail map.

> RIVER
> I told you to bring the trail map.

> ULA
> I forgot.

> RIVER
> You forgot?! I brought everything else,
> literally everything else, and all I
> asked you to bring was one thing: the
> trail map.

> ULA
> I didn't think it was that important.

> RIVER
> What do you mean not important? We're
> lost!

> ULA
> If we're on a trail, even if it's not
> the right trail, we're not lost.

> RIVER
> I don't know what you're talking about.
> We could be anywhere, heading nowhere.
> How could you not bring the map?!

> ULA
> I don't have the map and I can't change
> that now, so why don't we get off that?

> RIVER
> But we don't have it and now we're lost.
> We should probably just go back.

> ULA
> We're *not* lost. I'm going forward. You
> want to go back, go back, but don't come
> with me unless you're going to shut up
> about the stupid map.

Ula stalks off. River stands for a long moment looking back and
forth, before finally following Ula.

Trini sits across from Syl, and fidgets.

> SYL
> Look, something's clearly on your mind.
> Why don't you just spill it?

> TRINI
> I think it's over with Jean.

> SYL
> Are you kidding? You two are *great*
> together. What happened?

> TRINI
> There's... someone else.

> SYL
> You're kidding! You like cheated on
> Jean? I can't believe that.

> TRINI
> It's not like that. I... fell in love.

> SYL
> Poor Jean. Have you broke the news yet?

> TRINI
> I don't think I can. Should I?

> SYL
> Are you in love with this other person?

> TRINI
> Definitely.

> SYL
> And they're in love with you?

> TRINI
> Definitely.

> SYL
> It sucks, but you have to come clean and
> end things. Don't feel bad. Jean must
> have some part in this or you would have
> never... It takes two... right?

> TRINI
> Thanks. I'm *so* glad you said that. It
> makes things a *lot* easier.

 SYL
 Sure. The heart wants what the heart
 wants, right? Who is it, by the way?

Trini hesitates.

 TRINI
 Dana.

 SYL
 Dana? *My Dana*?

Trini nods "yes."

 SYL
 Are you serious?

 TRINI
 Yeah, should I have told you?

 SYL
 So you... and Dana...

Trini nods "yes."

 SYL
 How could you?

 TRINI
 It takes two, remember?

 SYL
 What?

 TRINI
 I mean you play some part in this or
 Dana would have never...

 SYL
 Are you kidding? I just said that to
 make you feel better—out of loyalty—
 something you clearly know nothing
 about.

 TRINI
 So I shouldn't tell Jean?

Syl storms out. Trini wants to yell after, but struggles for
the words.

 TRINI
 The heart wants what the heart wants...?

McKenzie and Ronny are sitting across from each other.

> MCKENZIE
> Where are we at?

Ronny looks around at their surrounding for a moment.

> RONNY
> I'm guessing you know where we actually
> are and mean that more figuratively?

> MCKENZIE
> In your mind, where is our relationship?

> RONNY
> I don't really think that way.

> MCKENZIE
> Okay... so just letting it *wash* over you
> and going with the *flow* or whatever?

> RONNY
> Something like that.

> MCKENZIE
> And as you float along it never occurs
> to you look up and see where you are?

> RONNY
> Don't appreciate the sarcasm, and look,
> if I was someplace I didn't want to be,
> I think I'd feel it, right? I wouldn't
> have to analyze it.

> MCKENZIE
> So you're okay where you are? Where *we*
> are?

> RONNY
> Yeah. You?

> MCKENZIE
> I'm just not sure we're where we should
> be—at this point.

> RONNY
> Where should we be? Like more committed
> or something?

> MCKENZIE
> Maybe.

 RONNY
 I'm committed. Are you not committed?

 MCKENZIE
 Maybe more settled?

 RONNY
 Like married? Is that what this is?

McKenzie gives Ronny an "Are you crazy?" look.

 RONNY
 Because it seems kind of early for that.

 MCKENZIE
 Who said anything about marriage?

 RONNY
 Then what? What about "where we are" are
 you unsatisfied with?

 MCKENZIE
 Who said I was unsatisfied?

 RONNY
 Then what is this all about?

 MCKENZIE
 I just want to know where we are.

 RONNY
 Okay. Why?

 MCKENZIE
 I... don't know... so I know we're in the
 right place, I suppose.

 RONNY
 What's the right place?!

 MCKENZIE
 I don't know that either. Obviously, I'm
 being stupid. I'm sorry. I'll try to go
 with the flow or whatever.

McKenzie tries to turn away, but can't avoid Ronny's hug.

 RONNY
 Where we're at is together. Let that be
 enough.

Tanveer walks in and finds Sullivan waiting angrily.

> SULLIVAN
> Where were you?

> TANVEER
> I had to pick up a prescription, and get some gas, and we were out of eggs, and—

> SULLIVAN
> Why weren't you *here*—for the party?

> TANVEER
> I don't like parties.

> SULLIVAN
> But it was a party for *you*.

> TANVEER
> I didn't ask for a party.

> SULLIVAN
> It was your birthday.

> TANVEER
> Even worse.

> SULLIVAN
> You know I planned this.

> TANVEER
> I told you *not* to.

> SULLIVAN
> I had twenty people here.

> TANVEER
> I told you not to invite anyone.

> SULLIVAN
> They were so disappointed.

> TANVEER
> If they know me at all, they weren't surprised I wasn't here.

> SULLIVAN
> It was *just* a party.

 TANVEER
 A party I didn't want and that I told you
 I wouldn't be a part of. If you threw it
 anyway, don't put that on me.

 SULLIVAN
 Why? Why aren't I allowed to make plans?
 Why is it *always* your way?

 TANVEER
 It isn't. You can throw all the parties
 you like, I am not trying to prevent
 you, but don't include *me*, and for God's
 sake, don't throw parties *for me*.

 SULLIVAN
 Don't you see how selfish that is?

 TANVEER
 No. I don't. It seems more selfish to
 throw a party for someone who doesn't
 want one just because *you* want one.

 SULLIVAN
 That's not why I did it.

 TANVEER
 No?

 SULLIVAN
 No. You need to be more social. It's
 getting weird. You're right, your
 friends kind of knew you wouldn't show,
 but they came anyway because they miss
 you and they're worried...

Tanveer has to consider this a moment.

 TANVEER
 So what did you say to these people when
 you invited them? Was this some kind of
 an intervention in your mind?

 SULLIVAN,
 We care. That's all. It should be a wake
 up call.

 TANVEER
 It is a wake up call, to the fact I need
 to get away from *you* too.

Tanveer storms back out. The air goes out of Sullivan.

Hurley and Karma lay close to each other on the floor.

> HURLEY
> You still awake?

> KARMA
> Yeah.

> HURLEY
> Why aren't you sleeping?

> KARMA
> I don't know. Thinking about tomorrow, I
> guess. Why aren't you sleeping?

> HURLEY
> Same reason, pretty much.

> KARMA
> What do you mean? You're not leaving.

> HURLEY
> I know, but you are. I suppose... I'm
> going to miss you.

> KARMA
> Really? It's not like we spend that much
> time together.

> HURLEY
> I think that was my mistake.

> KARMA
> That's nice.

Karma sees that Hurley is upset.

> KARMA
> What?

> HURLEY
> I'm saying, I should have told you how I
> felt and I never did.

> KARMA
> Whoa, what? How do you feel?

> HURLEY
> You sure you want to know? I mean,
> you'll be gone tomorrow.

Karma hesitates too long. Hurley turns away.

 HURLEY
 I didn't think you'd want to know.

 KARMA
 It's not that.

Hurley turns back.

 HURLEY
 I shouldn't have said anything. How
 could you feel the same about me?

 KARMA
 Don't say that.

 HURLEY
 Why not?

 KARMA
 I think maybe I made a mistake too. I do
 feel the same way, I always have, but
 I'm leaving. Is this a good idea now?

 HURLEY
 You feel like I do? You're not just
 saying that to spare my feelings?

 KARMA
 No, I do.

 HURLEY
 I could come with you.

Karma thinks for a moment.

 HURLEY
 Too much, right? I'm sorry.

 KARMA
 No. Let's do it.

 HURLEY
 Seriously?

They both laugh a long moment before settling back.

 HURLEY
 Wow. I'll never sleep now.

 KARMA
 Me neither.

Lee enters nervously.

MENLO
Thanks for coming in. Have a seat.

Lee and Menlo sit across from each other.

MENLO
We need to have a difficult discussion.

LEE
This isn't what I think it is, is it?

MENLO
Lee, you've got to let me speak here.

LEE
You *can't* fire me. You *can't*.

MENLO
There's nothing personal here. You know
what the financial situation is.

LEE
I *need* this job.

MENLO
Show me somebody around here who doesn't
need a job and you could make this a
whole lot easier for me.

LEE
Okay, fine, but I can show you people
who are worse employees.

MENLO
I don't think you want to turn on your
coworkers here. You've still got a great
reputation with me and I'm happy to write
you a recommendation.

LEE
So I should be grateful? No worries
about firing me, I'm just so darn
grateful for the recommendation.

MENLO
Are you sure you want to do this, leave
scorched earth? We may be rehiring in
the future.

 LEE
 Ha ha ha. You think I care what you
 think of me at this point?

 MENLO
 I'm thinking you don't.

 LEE
 That's right. In fact, you can screw
 yourself, screw yourself hard.

 MENLO
 I'm giving you a chance to leave on your
 own, otherwise I'm calling security.

 LEE
 You can't call security and you can't
 fire me.

 MENLO
 And why is that?

 LEE
 Because if you call security, I'll
 explain to them exactly why we're in
 financial trouble.

 MENLO
 What are you talking about?

 LEE
 Nice try, but you know exactly what I'm
 talking about and I have the e-mails.

They stare each other down a long moment till Menlo finally
breaks and smiles.

 MENLO
 I think you've misunderstood me. Did I
 make you think I wanted to fire *you*? I'm
 just... kind of brainstorming on cost
 control.

They trade insincere smiles for a long moment.

 LEE
 Right. I'll leave it to you, though.
 Money's your thing.

With this, Lee leaves.

 MENLO
 Sorry for the confusion.

Mallory is watching Taj, who is nearby in a chair.

> MALLORY
> You feel okay?

> TAJ
> Like I said, just a little shaky.

> MALLORY
> You sure you don't want to go to the
> hospital or something?

> TAJ
> I'm fine now... I'm sure.

> MALLORY
> How do you feel?

> TAJ
> I feel like I had a giant jolt of
> adrenaline, and I'm still buzzing.

> MALLORY
> You had a big scare.

> TAJ
> It was the scariest thing...

> MALLORY
> Scared me.

> TAJ
> I mean, I thought I was going to...

> MALLORY
> Maybe don't think about that now. You
> should probably concentrate on calming
> down, I think.

> TAJ
> Yeah. I'm sure you're right.

Taj takes some deep breaths.

> MALLORY
> You feel okay?

> TAJ
> You don't have to keep asking.

> MALLORY
> I don't know what else to do.

 TAJ
 It's a little unnerving.

 MALLORY
 Oh, sorry.

 TAJ
 How did you know?

 MALLORY
 You were turning blue.

 TAJ
 No, how did you know what to do?

 MALLORY
 Oh, gosh. I suppose because I was a
 junior lifeguard. They taught us all
 that stuff: Heimlich, CPR, first aid.

 TAJ
 I'm lucky you were a junior lifeguard.
 I'm lucky you were here at all. I mean
 if you weren't here...

 MALLORY
 Don't think about that.

 TAJ
 I mean, what am I supposed to do? I owe
 you my life.

 MALLORY
 I just did what... I mean, you don't owe
 me anything. I'm just glad I was here.
 So glad... I mean... I love you.

Taj looks up surprised.

 MALLORY
 I'm sorry. I don't know why I never said
 that. You know it, though, right?

 TAJ
 Of course. I love you too.

They take each other's hands.

 TAJ
 ...And not just because you saved my life.

They share a chuckle.

Jackson and Pat sit quietly. Both read the same book.
Jackson glowers and Pat smiles and occasionally laughs.

> JACKSON
> Really?

> PAT
> What?

> JACKSON
> This book is not that good.

> PAT
> I like it.

They go back to reading. After a moment, Pat laughs again and
Jackson gets angry.

> JACKSON
> You like everything.

> PAT
> Not everything.

> JACKSON
> But this?

> PAT
> Maybe you're not giving it a chance. Do
> you want to *not* like it?

Pat continues to beam. Jackson gets angrier.

> JACKSON
> I don't have to *try* not to like it. It's
> not that good.

> PAT
> I don't know. You like to be critical.
> I prefer to enjoy stuff.

> JACKSON
> Is it really that simple to you? You're
> way too smart to enjoy crap like this.

> PAT
> Crap to who? And even if it was crap,
> I'd rather enjoy it than be unhappy.

> JACKSON
> Aaaah! That's crazy! So do you have no
> taste at all? Do you care at all what
> you read, what you watch?

 PAT
Sure. I try to read good stuff, but I
try to enjoy anything I read or watch.
Why wouldn't I?

 JACKSON
Why would you enjoy something that is
just not good?!

 PAT
You're making yourself upset about this
the same way you make yourself unhappy
when you read or watch movies.

 JACKSON
That's not true.

 PAT
Do you want to be happy?

 JACKSON
Yeah, of course, everyone *wants* to be
happy.

 PAT
Not necessarily. I think you only truly
want to be happy if you work at it. Some
people just want to worry or want to get
angry or want to be *bitter*.

 JACKSON
So I should "work at being happy" by
liking things that suck?

 PAT
By trying to like something before
judging and condemning it. The math is
simple. The more stuff in life you like,
the happier you are.

 JACKSON
You are so naïve. Ignorance is bliss,
I guess.

Jackson stomps out grumbling. Pat goes back to reading.

 PAT
Really missing out...

193

Rickie runs in disheveled, startling Sol.

> RICKIE
> Sol!

> SOL
> What?!

> RICKIE
> I'm so glad you're here. I messed up
> bad.

> SOL
> What? What did you do?

> RICKIE
> I'm not sure if I should tell you.

> SOL
> I can't help you if you don't tell me
> what's going on.

> RICKIE
> I don't want to get you mixed up in it,
> make you an accessory or something.

> SOL
> Then why did you come here?

> RICKIE
> Where am I supposed to go? Aren't I
> welcome here?

> SOL
> Of course. I just meant why did you...
> tell me anything if you can't... you
> know... tell me everything?

> RICKIE
> You would have known something was
> wrong.

> SOL
> Probably, but if you can't tell me, you
> might want to stop talking about it.

> RICKIE
> Right. Okay.

Rickie tries sitting quietly a moment, but can't stop fidgeting.
Sol watches.

> SOL
Just tell me! If you're worried, you can
pretend you never told me.

> RICKIE
I hurt someone. I think they're
alright... I don't know for sure.

> SOL
You don't know?

> RICKIE
I was in a parking lot and I just looked
at my phone for a second. This guy came
out of nowhere... I couldn't do
anything... I wasn't going fast and I just
barely—I mean, I didn't hit him dead on.

> SOL
And you don't know if he was okay?

> RICKIE
I kept driving. I panicked.

> SOL
Go back now or call the police. You've
got to. Explain that you got scared.
I'm sure they'll understand.

> RICKIE
But my status, you know, they'll deport
me. I'll lose everything.

> SOL
This is bad, really bad.

> RICKIE
Right? I need to hide the car or
something. Can you help me?

> SOL
You were right when you didn't want to
mix me up in this.

> RICKIE
What? But I didn't know who else...

> SOL
Not me. Sorry. You need to go, and
remember, *you never told me*.

Rickie leaves ashamed. Sol feels guilty.

Phoenix and Lynn enter together.

> PHOENIX
> What did you mean when you said "you
> people" in there?

> LYNN
> Did I say that?

> PHOENIX
> Yes.

> LYNN
> So.

> PHOENIX
> What did you mean?

> LYNN
> People like Alton.

> PHOENIX
> Like Alton in what way?

> LYNN
> Where are you going with this?

> PHOENIX
> It sounded racist...

> LYNN
> Racist?

Phoenix nods "yes."

> LYNN
> How can I be a racist?

> PHOENIX
> By saying "you people."

> LYNN
> I didn't mean it that way.

> PHOENIX
> How did you mean it?

> LYNN
> You know, liberals. It was a joke.

> PHOENIX
> Liberals?

 LYNN
 Yes, of course.

 PHOENIX
 That's not how it sounded.

 LYNN
 Well that's what I meant.

 PHOENIX
 People know what you said, not what you
 meant.

 LYNN
 Why is this such a big deal to you?

 PHOENIX
 It's not a big deal to you?

 LYNN
 No, I know I'm not a racist.

 PHOENIX
 Do you?

 LYNN
 Are you trying to say I'm a racist?

 PHOENIX
 You said what you said.

Lynn stares at Phoenix in disbelief.

 LYNN
 Just leave.

 PHOENIX
 My pleasure.

Phoenix starts to leave.

 LYNN
 I don't know how you could say this
 about me. I thought you knew me.

 PHOENIX
 I thought I knew you too.

Phoenix walks out.

Kern is doing some stretching that clearly annoys Devin.

> DEVIN
> Do you have to do that in here?

> KERN
> You should probably join me. Some
> exercise wouldn't hurt you.

> DEVIN
> What is that supposed to mean?

> KERN
> Exercise is good for you and you don't
> do it much.

Kern continues to do various stretches.

> DEVIN
> Are you saying I'm fat or something?

> KERN
> How do you get that? Now if I told you
> to diet, maybe you could get huffy, but
> I said exercise.

> DEVIN
> Am I fat?

> KERN
> Most everybody can be in better shape. I
> sure can.

> DEVIN
> So then, yes, I am fat?

> KERN
> I just don't get that way of thinking.
> Is there some kind of line people cross
> and on one side of the line you're fat
> and on the other you're not fat.

> DEVIN
> C'mon, you never called anyone "fat"?

Kern pauses from stretching for a moment to consider this.

> KERN
> I'm not proud of this, but although
> there may be no clear line defining fat,
> there are some people where a fine
> distinction is not required.

 DEVIN
And me?

 KERN
...You are not even close to fat under
this definition.

 DEVIN
Thank you! Was that so hard?

 KERN
Frankly all this superficial "how do I
look?" stuff makes me uncomfortable. I'm
over it.

 DEVIN
Oh really? So you don't care how people
look?

 KERN
I'm sure there's part of me that can
still be influenced by appearances, but
for the most part I'm much more
interested in the content of people's
character.

 DEVIN
Wow. When did you have this
breakthrough?

Kern pauses again from stretching.

 KERN
Well, to be honest with you, one time,
Emory called me ugly. It really hurt me,
but at least it got me thinking.

 DEVIN
That's terrible. I'm so sorry. You're
not ugly.

 KERN
It's okay, Emory is a fat pig anyway.

Devin is shocked at first, then they both laugh.

 DEVIN
You know Emory is about my size.

 KERN
Stop. Please just stop.

Chilton walks by Yuki without saying anything.

 YUKI
 So you don't talk to me anymore?

 CHILTON
 Hmmm? Oh, I didn't see you.

 YUKI
 So you don't *see* me anymore?

 CHILTON
 Ha, ha. Always *so dramatic*, Yuki.

 YUKI
 Seriously what happened?

 CHILTON
 I don't know what you mean.

 YUKI
 We used to be friends, good friends, and
 now you won't even say hello to me.

 CHILTON
 Hello.

 YUKI
 That's not funny.

 CHILTON
 Please, you're just making something out
 of nothing.

 YUKI
 Am I? When's the last time we did
 anything together? When's the last time
 you even texted me?

 CHILTON
 Needy much?

 YUKI
 Never mind. I don't know why I bothered.
 I thought maybe since we used to be
 friends...

 CHILTON
 Look, we're just different people now.

 YUKI
 Yeah, you're a *snob* now.

 CHILTON
 Let's not start name calling.

 YUKI
 I might actually like that. I'd like you
 to just go ahead and tell me what it is
 about me that you don't like anymore?

 CHILTON
 It's just you're so... emotional.

 YUKI
 Okay, I am, but is that a bad thing?

 CHILTON
 It is for the people who have to deal
 with you.

 YUKI
 Wow. Well, I appreciate your honesty in
 a way. At least now I know what happened.
 I'll leave you alone.

Yuki turns away and Chilton starts to go, but can't help
looking back.

 CHILTON
 Look, I don't think I'm a snob—I don't
 want to be. I don't even mind that
 you're emotional, but other people...

 YUKI
 So you won't hang out with me anymore
 because of what other people think?

 CHILTON
 Basically. It doesn't say much about me,
 does it? So don't feel bad. It's not
 your fault.

 YUKI,
 I still feel bad. I miss you.

 CHILTON
 Don't make me feel worse. I'll see you
 around.

Chilton walks away.

 YUKI,
 Even if you don't say hi?

ABOUT THE AUTHOR

A prolific filmmaker and accomplished educator, Dave Kost has written, directed, and acted in numerous varied and award-winning short films. His films have played in festivals and on television around the world. He is a professor at Chapman University where he has taught filmmaking, directing, and acting since the founding of the Dodge College of Film and Media Arts. At Chapman, he helped to build the university's world-renowned graduate and undergraduate film programs and created the first of its kind BFA degree in Screen Acting, an interdisciplinary degree offered between Chapman's theater and film departments. Prior to Chapman, Kost worked extensively in film and television and was founding faculty at the New York Film Academy. Kost is also the creator of an internationally distributed instructional video about safety on film sets and a documentary about Ivanna Chubbuck, acting coach to the stars. He is most proud of this book's predecessor, *Book of Sides: Original Scenes for Actors and Directors*. It is being used at film and theater schools across the country. Dave received his MFA from New York University's prestigious graduate film program.